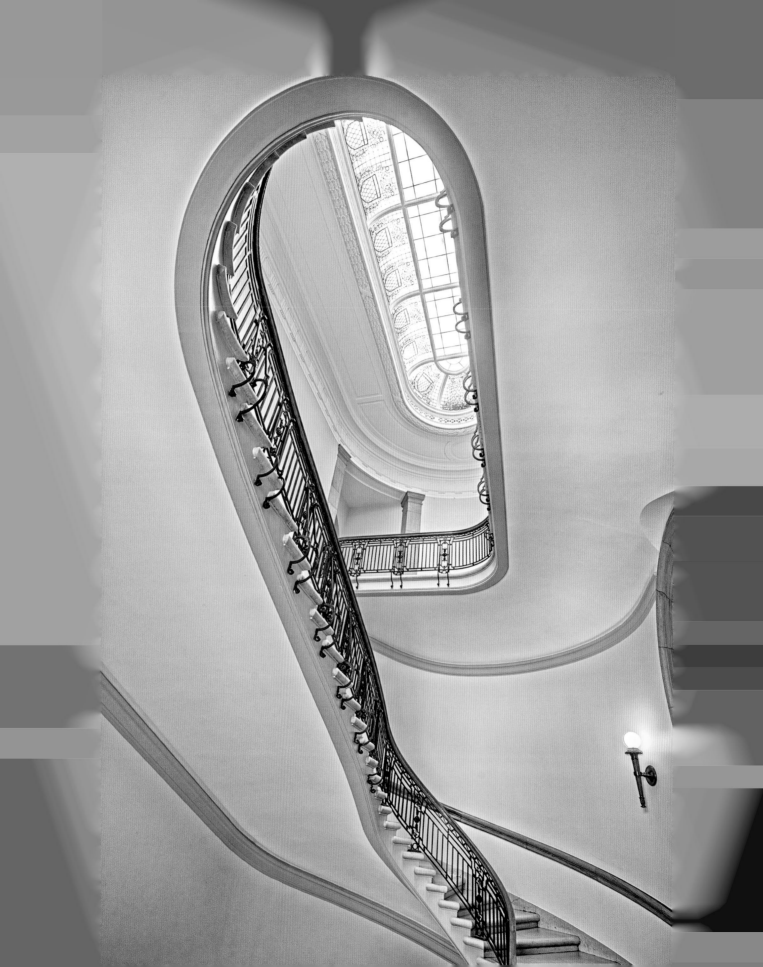

Our Minnesota State Capitol

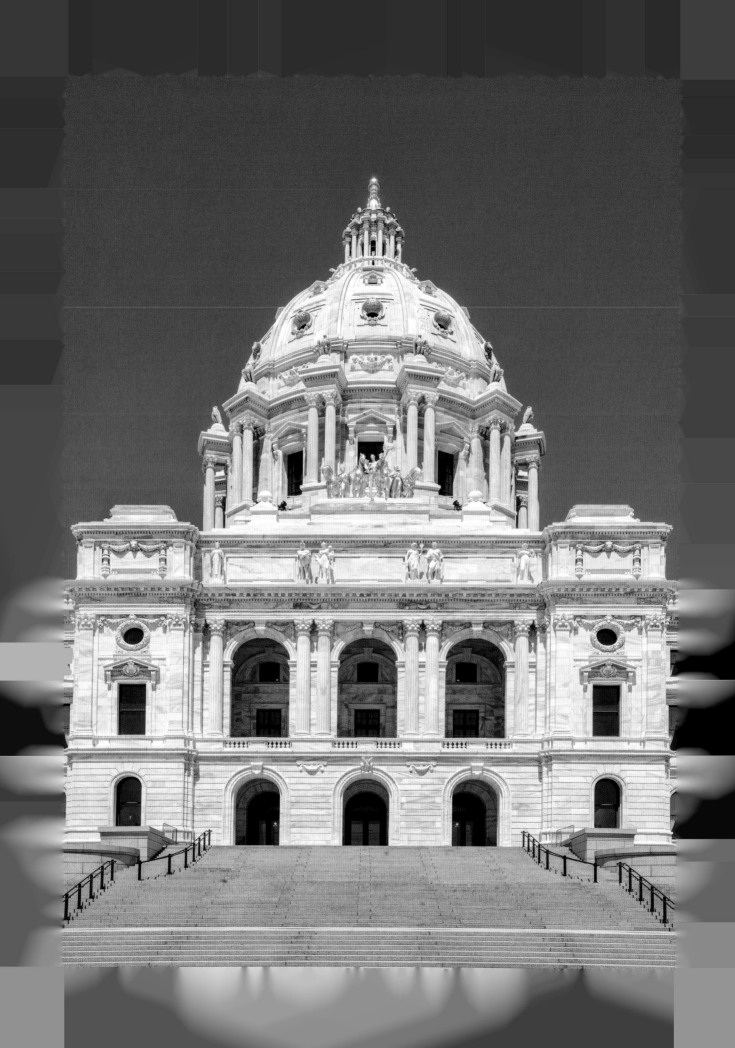

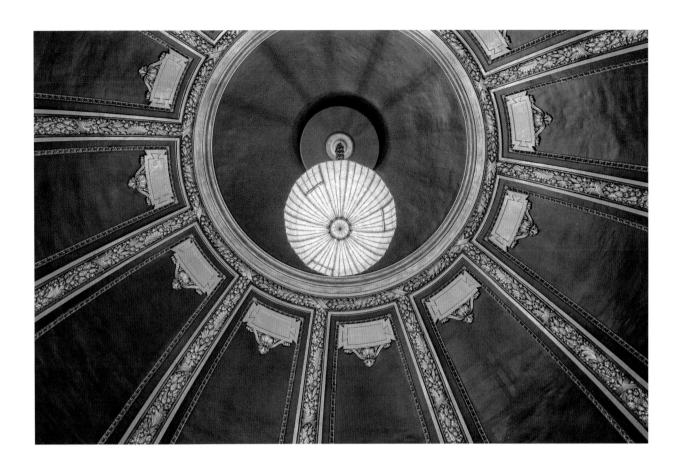

OUR MINNESOTA STATE CAPITOL

FROM GROUNDBREAKING THROUGH RESTORATION

DENIS P. GARDNER

Foreword by Governor Mark Dayton

MINNESOTA HISTORICAL SOCIETY PRESS

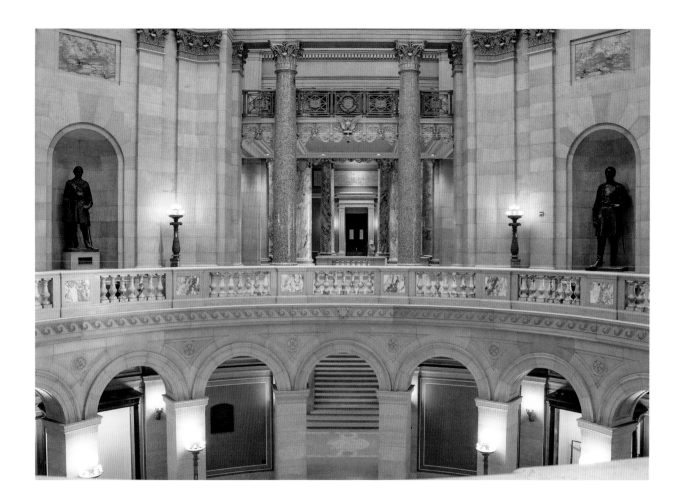

www.mnhspress.org

The Minnesota Historical Society Press is a member of the Association of American University Presses.

Manufactured in the United States of America

10 9 8 7 6 5 4 3 2 1

♾ The paper used in this publication meets the minimum requirements of the American National Standard for Information Sciences—Permanence for Printed Library Materials, ANSI Z39.48-1984.

International Standard Book Number

ISBN: 978-1-68134-041-8 (paper)

Library of Congress Cataloging-in-Publication Data

Names: Gardner, Denis, 1965– author.
Title: Our Minnesota State Capitol : from groundbreaking through restoration / Denis P. Gardner ; foreword by Governor Mark Dayton.
Description: Saint Paul, MN : Minnesota Historical Society Press, 2017. | Includes bibliographical references and index.
Identifiers: LCCN 2017019133 | ISBN 9781681340418 (pbk. : alk. paper)
Subjects: LCSH: Minnesota State Capitol (Saint Paul, Minn. : 1905–) | Gilbert, Cass, 1859–1934. | Eclecticism in architecture—Minnesota—Saint Paul. | Public buildings—Conservation and restoration—Minnesota—Saint Paul. | Saint Paul (Minn.)—Buildings, structures, etc.
Classification: LCC NA4412.M6 G37 2017 | DDC 720.9776/581—dc23
LC record available at https://lccn.loc.gov/2017019133

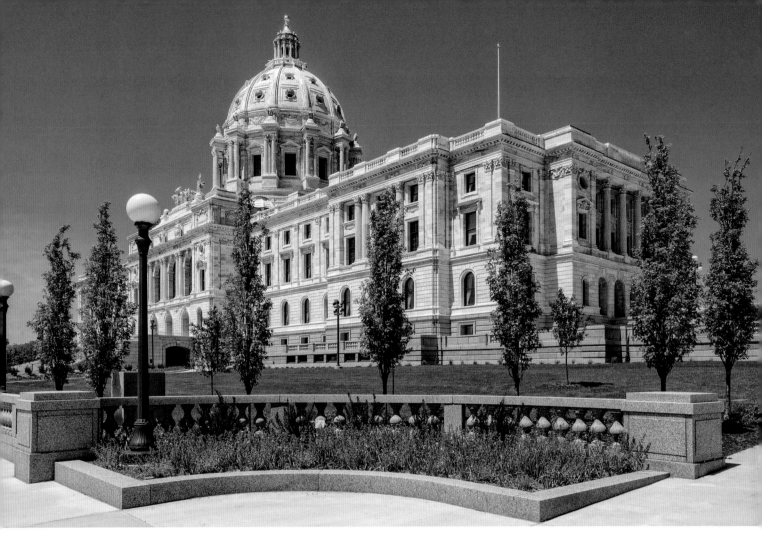

CONTENTS

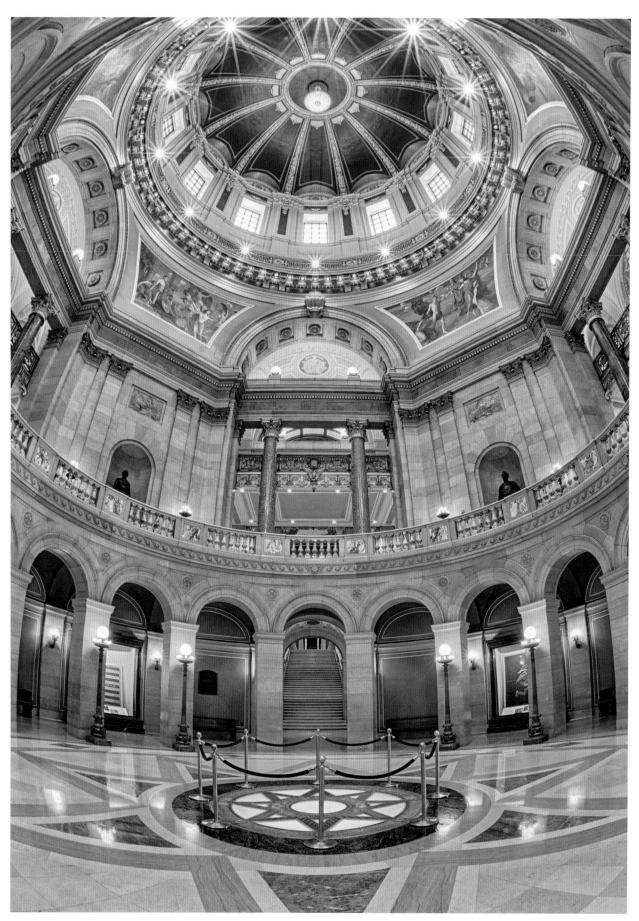

The capitol rotunda.

FOREWORD
Governor Mark Dayton

The Minnesota State Capitol is one of the most beautiful public buildings in the United States. Since its completion in 1905, visitors have been awed by its art and architecture, its magnificent spaces, intricate stonework, and striking murals.

Denis Gardner tells stories of the people who built the capitol; who have worked, celebrated, and protested here; and who have now restored it. Historical photos remind us of what happened here, and modern photos show off the restoration. Gardner's book documents this great building's story.

Minnesotans have come to their capitol to debate important issues for more than a century. It is where women gained the right to vote in 1919. Where the Minnesota Miracle, which transformed public education, became law in 1971. And where Marriage Equality was finally legalized in 2013.

But by May 2011, the capitol was showing its age, the result of over a century of heavy use, inadequate heating and cooling systems, and air pollution. That month, however, after thirty years of studies and planning, a bipartisan majority of legislators voted to begin a multiyear project for the restoration, preservation, and maintenance of the capitol. They recognized the urgent need to repair crumbling stones and a leaking roof; replace antiquated plumbing, mechanical, and electrical systems; and rethink the use of its space.

After six years of diligent restoration, the capitol has been preserved for its next hundred years of use. The exterior marble shines with warm, earthy tones. The quadriga glitters. The building's underlying systems are modernized, while its architecture is preserved. Energy efficiency, information systems, space for educational programming, and access for citizens—all are vastly improved. The building is sound, safe to work in and to visit.

The beauty and craftsmanship of the capitol is a testament to the talent of the original workers, who labored for years, without the benefit of modern construction equipment, to complete it. The restoration has been similarly masterful; the capitol has been restored to its former glory. The thousands of Minnesota craftsmen and construction workers who completed the restoration project deserve our gratitude.

The people of Minnesota also deserve our thanks. They endured years of disruptions and reduced access to their capitol. They gladly supported the restoration work with their tax dollars. The result is priceless. The capitol is once again a public building in which all Minnesotans can take enormous pride.

In this building, we see ourselves in history, in the flow of everything that has brought us to where we are today. We can evaluate the actions of our predecessors—and we know that we, too, will be judged for how wise, innovative, and courageous we have been. Our responsibility is a profound one: to bestow upon our children and grandchildren the opportunities for better lives.

This superb restoration is an inspiring reminder of the enduring values that were at the heart of its design; and it will serve Minnesota well, now and for generations to come.

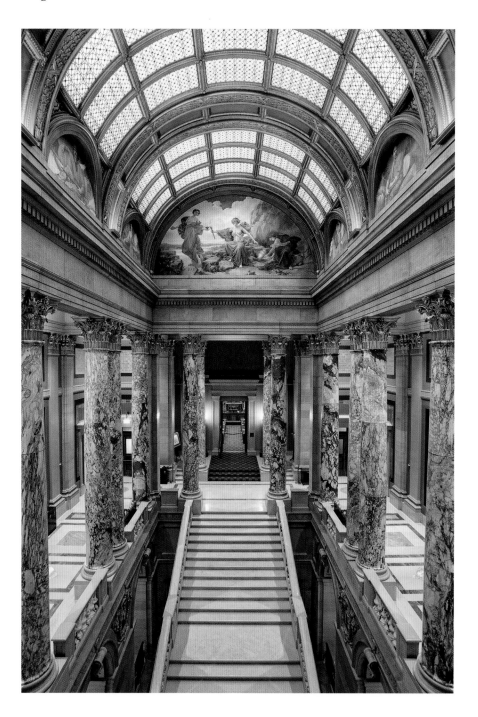

West grand stairway.

INTRODUCTION

The weather in St. Paul was pleasant on the morning of May 6, 1896. You can see it in the photo. The men are wearing light coats, some in suit coats over vests. Almost all are wearing hats, many in bowlers and homburgs, but others in boaters or some other style. A few women may have been present, but they are nearly impossible to spot in the sea of serious-looking male faces wedging itself tightly within the frame. The most important face, the subject of the photograph, is plainly evident. Absent his suit coat, Channing Seabury has not bothered to roll up his sleeves or remove his vest or tie, but then, the graying, distinguished-looking gentleman has not needed to labor long, for a simple shovel of dirt and a brief pause for the camera is enough to officially begin construction of the Minnesota State Capitol, designed by St. Paul architect Cass Gilbert.

Channing Seabury, vice president of the Board of State Capitol Commissioners, holds the shovel at the groundbreaking ceremony for the Minnesota State Capitol, May 6, 1896.

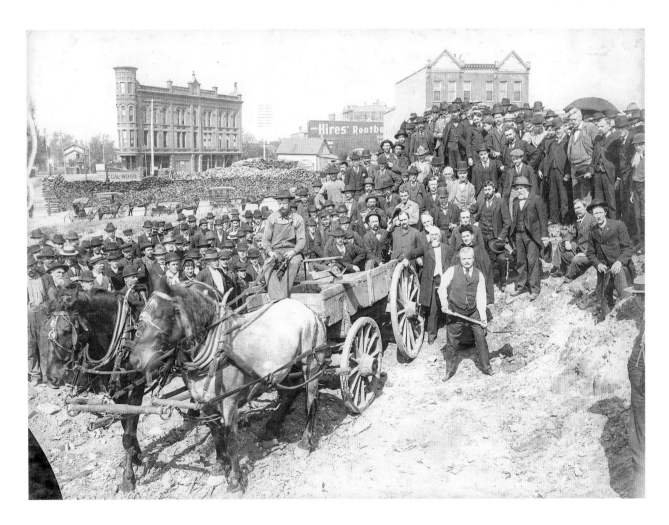

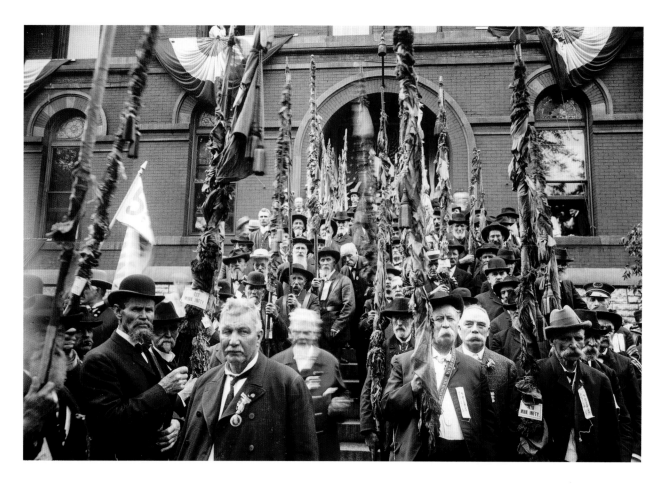

Civil War veterans remove regimental battle flags from the old capitol to the new one, June 14, 1905.

Nine years later, on June 14, 1905, Minnesota Civil War and Spanish-American War veterans marched five blocks in parade from the old capitol building to the newly completed one. Although the legislature had held its first session in the handsome statehouse in January of that year, the festive event represented a kind of grand opening of the capitol. Governor John A. Johnson had issued an executive decree proclaiming June 14 "Flag Day," and the celebration marked the formal transfer of regimental battle flags from the previous capitol to the new one.

The ceremony included another first for the new building: the honoring of a deceased Minnesotan. The body of Colonel William Colvill, who had died only two days earlier, was reverentially set out in the rotunda and later moved to the building's administrative wing. In 1863, Colvill had famously led the charge of the First Minnesota Regiment at Gettysburg, where more than 80 percent of the Minnesotans were killed or wounded—but the Confederates were slowed and the Union Army was saved. As a proud veteran, Colvill had journeyed to St. Paul to attend the Flag Day event with cherished comrades, but now his role in the proceedings was more profound. Pride, surely, was a character of the day, but the more than one thousand veterans in attendance also recognized the melancholy of the moment, for time was drawing down on them as well.

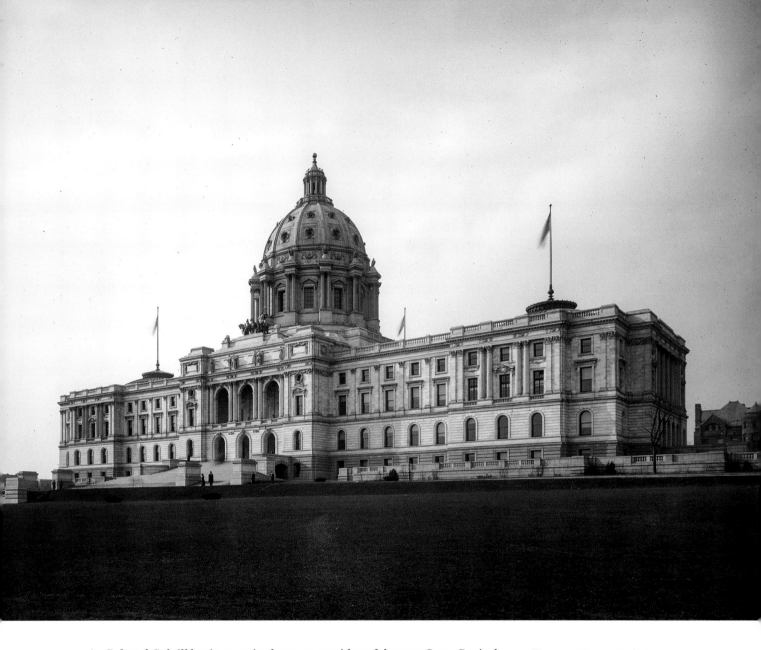

The new Minnesota State Capitol, about 1906.

As Colonel Colvill lay in state in the west corridor of the new State Capitol, and as veterans of the Civil War and Spanish-American War marched proudly up Cedar Street to greet him at his temporary quarters with beaming crowds peering on, it was plain that Minnesota had much to celebrate. Not only had regiments from the state helped secure victory in the war between the states, but since the conclusion of that great conflict, the notions and ambitions of Minnesotans had turned the state into a region of wealth and opportunity. In essence, during the period from the close of the Civil War to the opening of the new century, the potential of Minnesota became crystal clear. Unwilling to rest on its laurels, a far-sighted population punctuated its maturity with a stunning garnish, the new Minnesota State Capitol.

Through subsequent years, Minnesota's changing needs, plus normal wear and tear, brought two renovations and a partial restoration of this beautiful building. And a little over a century later, the capitol would be restored to its original glory.

PREQUEL TO A MONUMENT

What *was* Minnesota as it took on this project? It is dizzying to consider the changes in the state in the last half of the nineteenth century. In 1858, when Minnesota became a state, its population measured roughly 172,000; by the time Channing Seabury broke earth with his shovel, Minnesota claimed more than 1.7 million residents. Their ethnicities were many, reflecting especially the heavy immigration from Germany and Scandinavia during those years, but all of Europe was included; metropolitan areas had small but vital African American communities and small numbers of people from other countries around the world.

The state is a natural transportation hub, with the Mississippi, Minnesota, and Red Rivers, as well as Lake Superior, providing access to three continental watersheds. St. Paul, at the head of navigation on the Mississippi, was the break-in-bulk point for goods and immigrants transferring from riverboats to railroads and traveling west across the state and the continent. The Great Northern, the Northern Pacific, and the Minneapolis, St. Paul and Sault Ste. Marie—the Soo Line—were all railroads headquartered in Minnesota.

The state's natural resources provided enormous wealth for those who developed them. Lumbermen cut down vast forests of white pine, from the St. Croix Valley throughout northern Minnesota, and sawed them into the lumber that built the towns of the Midwest and West at the Falls of St. Anthony in Minneapolis. The infant industry generated roughly $58,000 in 1850, but by 1900, it had grown to $40 million a year. The iron mines of northern Minnesota began shipping ore in the 1880s and 1890s. Shipment of millions of tons per year soon became the norm and remained so for decades.

But it was agriculture that proved the chief industrial driver in Minnesota. Thousands of men and women who desired to farm journeyed to rich, fertile cropland in the state's south, southwest, and northwest. Much of the state was a garden bed. In 1862, four years after Minnesota became a state, the US Congress passed the Homestead Act. Any citizen could claim 160 acres, make improvements, live on the land for five years, and then own it. Land speculators found ways to claim and resell large tracts, but the opportunities were irresistible for children of farmers in the eastern United States and land-hungry Europeans. Wheat became the first great crop, and new mills built at the mighty Falls of St. Anthony made Minneapolis the flour-milling capital of the world.

The growth of major industries spawned a boom in smaller businesses to supply their needs and those of their workers. Inventions in milling technology and business practices, improvements in transportation, powerful banks and insurance companies, the arrival of electricity in the 1880s—all

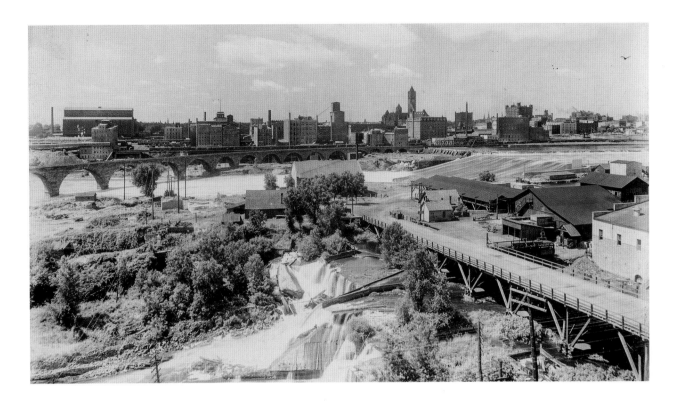

demonstrated that Minnesota was indeed worthy of national and international prominence.

But this prosperity rested on a difficult history. European Americans essentially invaded the homelands of Dakota and Ojibwe people, and the newcomers considered their use of the land to be better than the uses its indigenous occupants were making. Minnesota's territorial and state leaders, representing the US government, had forced the Ojibwe and Dakota people to sign treaties ceding land for promised payments that often were not delivered. By the 1890s, Ojibwe people occupied seven reservations in northern Minnesota. For the Dakota, who had responded to broken treaties in 1862 with a brutal war, the land loss was even greater. They had been exiled to states farther west, and only a few small Dakota communities still existed in southern Minnesota. The tribes retained their sovereignty as "dependent nations," however.

Minnesotans, like other Americans, framed the story as the inevitable victory of a powerful and superior culture over primitive people who must assimilate or disappear. As the state's leaders prepared to celebrate the state's wealth and growth in their new capitol, they quite naturally looked to their own European heritage for architecture, art, and culture. Europe offered beautiful structures that represented the history of democracy—as well as allegorical ways to tell even the most difficult of the state's stories.

As Channing Seabury picked up the shovel, both he and Cass Gilbert knew that the palace to democracy that began with that modest scoop was to reflect a dynamic state that had arrived. And they must have assumed that the building and the state would both still be beautiful, if different, more than a century later.

Sawmills, flour mills, the Stone Arch Bridge, and the Minneapolis skyline reflect the growth in the state's agriculture, industry, and transportation networks, about 1898.

PLANNING MINNESOTA'S CAPITOL

Minnesota's first capitol, a pedestrian Greek Revival–style statehouse, was completed in 1854 at Tenth and Cedar Streets. It burned in 1881, taking much of the state library and some of the collections of the Minnesota Historical Society with it. The legislature met in the still-unfinished second capitol, built on the same site, in 1883. It also featured classical architectural elements but with a Victorian air. Almost from the time it was erected, it was thought too small for the state's business. Both buildings were modest, perhaps appropriate for their time, but neither carried the tasteful grandeur that might assert the cosmopolitanism of its planners.

Channing Seabury was the vice president of the Board of State Capitol Commissioners, a body appointed in 1893 by then-governor Knute Nelson to oversee the construction of a new capitol. Nelson—who was the president of the board *ex officio*—was following a recommendation of the state legislature, which had established a committee for investigating the need for a building. The committee recommended its construction, and the legislature subsequently passed legislation procuring at least $2 million for the task. The seven

Minnesota's first capitol building, on the block bounded by Wabasha, Cedar, Tenth, and Exchange Streets, about 1865.

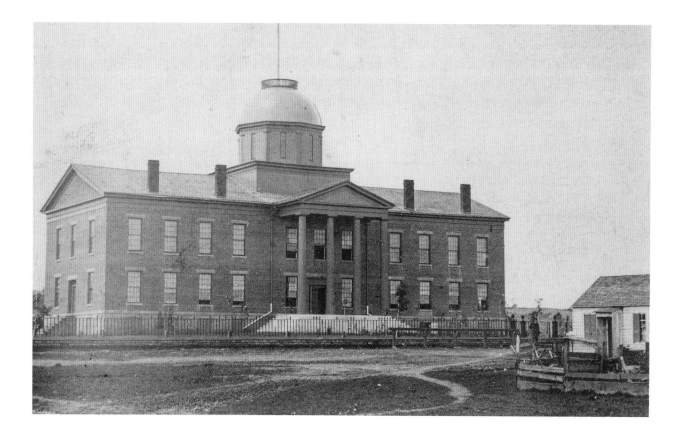

The state's second capitol building, built on the same site, about 1890.

members composing the Board of State Capitol Commissioners were drawn from the state's seven congressional districts, although over the relatively long existence of the body, a total of eleven different members would serve. From beginning to end, however, Seabury was a constant, serving the entire term of the board's existence as its vice president, a role that for all intents and purposes forced him to shoulder the yoke and carry the project to completion.

Seabury, who would die only a few years after the capitol was finished, proved a wise choice to guide the board. Like most of the original members, he was of the Civil War generation. Born in Massachusetts in 1842, Seabury was a business apprentice in New York City by his late teens. At eighteen, he relocated to St. Paul to seek the financial promise of Minnesota and escape the "family disease" of tuberculosis, the latter incentive stressed by his sister, Caroline. He soon was employed by the local wholesale clothing enterprise of J. C. and H. C. Burbank and Company, for which he eventually became a partner. Achieving his goals did not come quickly, however, a fact made evident in correspondence to family during and soon after the Civil War, when he expressed longing for a dwelling of his own. Eventually, desire and hard work brought him financial success and marriage. After his first wife, Frances W. Cruft, passed away, he wed Elizabeth P. Austin in 1883, one year after partnering in Maxfield, Seabury and Company, a wholesale grocer that became Seabury and Son in 1891.

Forever civic minded, Seabury thrust himself into efforts to benefit others less fortunate. He chaired the relief committee that assisted the rebuild of Sauk Rapids after it had been destroyed by a tornado in 1886. Six years later, he chaired the relief committee that helped reconstruct Hinckley after it was destroyed in the Great Hinckley Fire of 1894.

Although Seabury never managed a civic endeavor so substantial as erecting a state capitol, plainly the demands of the task did not find him unprepared. Nevertheless, overseeing the erection of a state's principal public edifice is fraught with hazards, not least of which are the competing egos, some to be massaged and others manhandled. Throughout the duration of his fourteen-year, nonsalaried commitment, Seabury found that he must make such choices, perhaps most notably when he was compelled to side with the architect's desires over those of other members of the Board of State Capitol Commissioners. His skirmishing with some board members was frequent, but in the end, all took consolation in the striking Renaissance conclusion to their efforts.

On January 1, 1895, the board offered its First Biennial Report, a commentary explaining that four sites for a capitol building had been studied. One site included the land of the existing capitol building at Exchange and Wabasha Streets but incorporated another acre just to the north of the site. Another site was located about two blocks to the southeast of the existing capitol, while a third was about six blocks to the northeast. The fourth was bounded by Park Avenue, University Avenue, Cedar and Wabasha Streets, and Central Avenue. Even though acquisition costs for any one of the sites was unreasonable, the board concluded that the fourth option was the best location for the building. It also was the costliest. Rather than pay the $480,000 that the seventeen owners asked, the board approached owners separately, convincing twelve of them to accept the value of their property as appraised by three of the city's stalwart citizens, Henry S. Fairchild, Henry M. Rice, and historical heavyweight Alexander Ramsey, Minnesota's first territorial governor. While condemnation proceedings were required in some instances to complete the transaction, the tract was secured for a little over $285,000.

While negotiations for the site were ongoing, the board turned its attention to selecting an architectural design for the building. The board advertised for designs in early June 1894 and by October had received fifty-six submissions. Understanding its limitations, the board welcomed the assistance of advising architects Edmund Wheelwright of Boston and Henry Ives Cobb of Chicago. Of the fifty-six submissions, precisely none impressed the architects. Nevertheless, the two architects picked what they believed were the five best, even though they continued to insist that none were deserving of superlative construction materials, such as granite or other fine stone. In correspondence with the legislature, the board made plain that burdensome design restrictions imposed by the legislation enabling a new capitol building undermined the appeal of the final product.

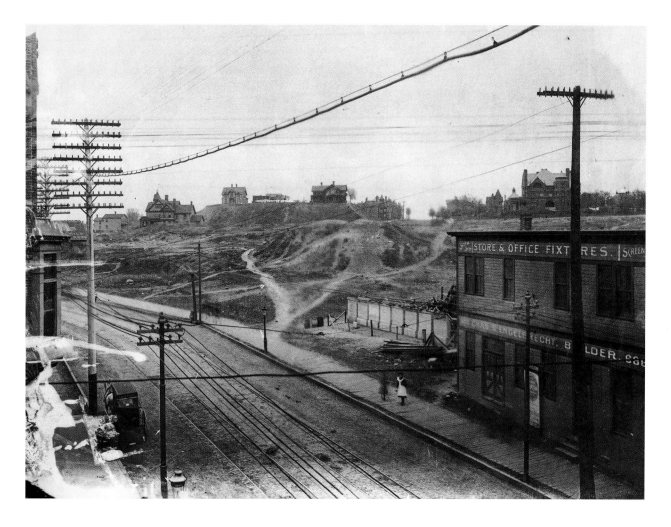

Looking north from Wabasha Street to the site for the new capitol, about 1896.

In part, the board was influenced to this view by architect Cass Gilbert and the Minnesota Chapter of the American Institute of Architects, which he headed. Gilbert lamented the paucity of funds for construction and the architect's limited control of the project. He personally complained to Seabury, while he and other architects publicly complained to others. In its correspondence, the board essentially asked the legislature what it wished to symbolize Minnesota: a blue-ribbon Aberdeen Angus or a milch cow? Thankfully, rightfully, the legislature chose the Angus. It revisited the original enabling legislation, altering specific requirements to make certain that the capitol ultimately produced was worthy of the great state of Minnesota.

On April 11, 1895, the board officially rejected all of the designs that were submitted in 1894, and within a few days they explained the new requirements and advertised for new designs. By early August, forty-one designs had been submitted to the board, with Wheelwright proclaiming that the quality of the designs was superior to what had come before. The board concluded that five designs surpassed the rest, including that of George R. Mann of St. Louis, as well as those of Minnesota architects Clarence H. Johnston; Bassford, Traphagen and Fitzpatrick; Harry Wild Jones; and Cass Gilbert.

For two days, the board voted on the designs, but no architect won a majority. Unable to pick a candidate by ballot, Seabury introduced a resolution ranking the architects, with Gilbert ranking first. The board accepted the resolution. The selection process was questionable, and the other finalists grumbled, but Cass Gilbert was awarded the commission.

ALL OF THE DESIGNS were similar to some degree, each and every one embracing traditionalism as expressed in domes, columns, loggias, and the like. Each could find home in Europe, except that each could not, for all were uniquely American, adopting that most New World of architectural habit whereby Old World aesthetics are made louder, brasher. Indeed, the design of Harry Wild Jones was positively exuberant, the five domes punctuating its pinnacle like well-inflated balloons. It was plainly handsome, but it was plainly brassy, which likely explains why it was the fifth-place design. The others were more reserved, but only slightly. Garishness was revealed in each building's crown, but it seemed right, for while we had thrown off monarchy, we could not entirely throw off regal trappings, surely not in a public edifice dedicated to a people whose recent memory ran eastward across a broad ocean to largely European homelands.

Of the five designs, Gilbert's was perhaps the most formal, the interruptions of the long plane of the façade apparent, but less so in contrast with the others. The formalism was reinforced with a loggia crowned only by an entablature, this in opposition to all other designs, which continued the upward movement of the primary entry with the addition of a pediment. Gilbert hardly neglected ornament, however. Indeed, his design was awash in it, as virtually every plane was embellished in a manner masking the plane. This characteristic was even more pronounced once the building was completed, as the veiny, polychromatic nature of the lightly hued exterior stone implied a texture to otherwise smooth, flat surfaces.

Gilbert's name, unlike Seabury's, has always been synonymous with the Minnesota State Capitol. It is unsurprising, for it is the architect who creates society's most public form of art. A renaissance personality—and our third president—implied as much. Thomas Jefferson was many things, and chief among them was architect. In fact, he designed much of the campus of the University of Virginia. Although Jefferson welcomed painting and statuary, he implored Americans visiting Europe to study primarily architecture, which was "among the most important arts," for we were building a new nation, and we had little time or money for artful eccentricity. He also considered "Painting, Statuary. Too expensive for the state of wealth among us . . . worth seeing but not studying." By the time Gilbert was drawing his plans for the capitol, however, Minnesotans were plainly in less rush and had more coin; Gilbert decorated the building with all manner of statuary and paintings, the most conspicuous being the golden quadriga atop the entablature over the main entrance.

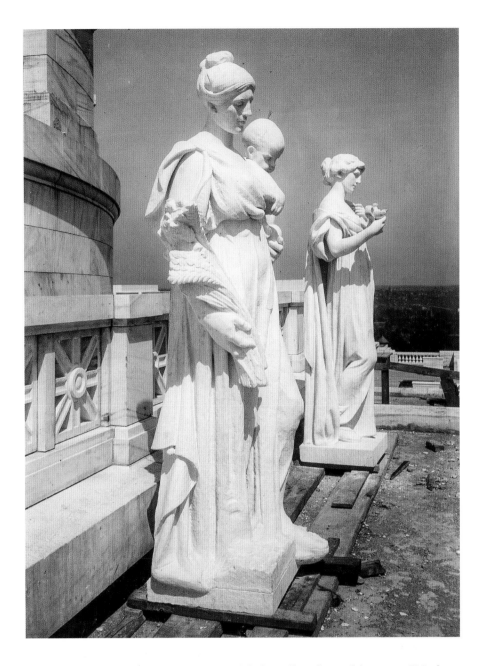

Cass Gilbert scholar Sharon Lee Irish describes the architect as a "Modern Traditionalist." She explains that "Modern Traditionalists valued the authority of older, historical architecture and used these examples as precedents for their own designs. The rules, culled (usually) from Old World prototypes, were not rigid; rather, precedents served as guidelines and medieval, Renaissance, and Baroque motifs were freely interpreted."

Architects who embraced this design philosophy were not unusual in Gilbert's day, as it was an age of remade classicism, initiated in some manner by the grand spectacle of the 1893 Columbian Exposition in Chicago. Dressed in exaggerated architectural togas of the Greeks and Romans, the buildings of the World's Fair astounded both the general public and professional designers.

Many architectural practitioners of this period were seeking revival of the Italian Renaissance through creative interpretation of classical forms and themes, often as applied to public buildings. The Library of Congress, completed shortly after the world gathering, was one of the first buildings to mirror in large scale the idealism expressed at the fair. The Columbian Exposition also illustrated the beauty possible when fine architecture and community planning are intimately bound. The fair's pleasurable aesthetic of splendidly detailed façades, promenades, and statuary, integrated within a meticulously designed landscape, substantially contributed to the rise of the City Beautiful movement, whereby designers, planners, government officials, and others embraced the notion of the community itself as a work of art. It was within this context that Gilbert and his contemporaries operated, and so it was hardly surprising that he and the others seeking the capitol commission employed the design language of the Beaux-Arts, which so boisterously lauded itself in Chicago that summer of 1893.

These forms, the quintessential architectural language of Europe, were particularly attractive to American civic leaders of the day. The term Beaux-Arts is drawn from the École des Beaux-Arts, a school of design in Paris that is nearly four centuries old. As a school of architecture, the École des Beaux-Arts was without equal in the nineteenth century, drawing students from throughout Europe and the world. Richard Morris Hunt was the first American to attend the school, and he was followed by Henry Hobson Richardson, although Richardson was hobbled by lack of funding and never completed his course

A section of the south façade features an entablature embellished with modillions and dentils and resting upon pilasters and fluted columns crowned with capitals of acanthus; over the window at lower center, scrolled brackets support a pediment that is punctuated by a cartouche (to identify many of these features, see p. 26).

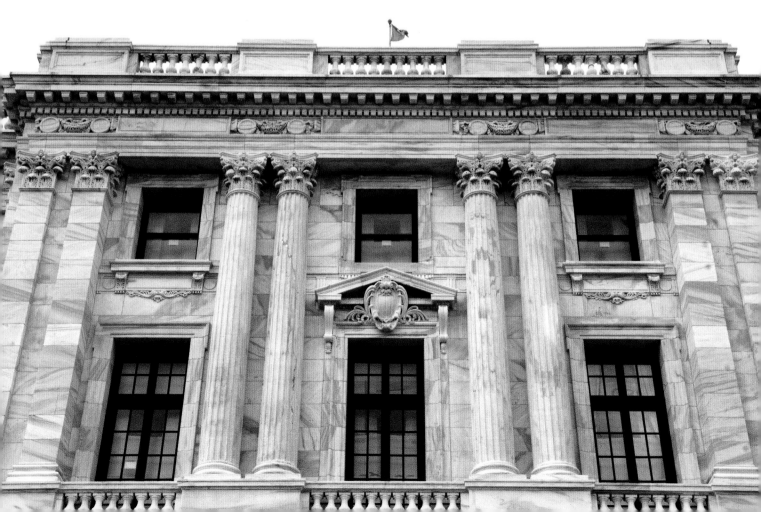

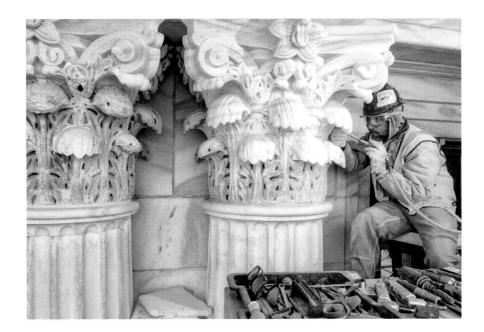

of study at the institution. Nevertheless, Richardson is credited with one of America's most prominent late-nineteenth-century architectural styles, the burly Richardsonian Romanesque. Of masonry construction, buildings exhibiting the Beaux-Arts design philosophy are in part defined by garish use of classical elements. Striking detail is blended with domes, paired columns, recessed arches, and the like. Column capitals of molded acanthus (the carved-leaf ornamentation so often seen in both woodwork and stonework) or scrolling are common, as are exquisite keystones that no Greek or Roman would ever have carved. Medallions and roundels punctuate wall surfaces, while building corners are textured with quoining. Fanciful roofline balustrades imply a kingly form, an impression reinforced by finely detailed statuary embellishing monumental entablatures or pediments, the tympanum of which are ornamented in low-relief pictorial narratives. The style often features art that is meant to inspire by employing classical symbolism and allegory. Although similar to the architecture of the ancient Mediterranean, this architectural classicism includes elements of the Renaissance, and it manifestly expressed what its adherents wished—that is, the inherent goodness of democratic society and the nobility of the thoughtful and progressive citizen within it. Because Beaux-Arts architecture achieved this goal so well, by the turn of the twentieth century it was employed for all manner of civic edifices.

And theological edifices as well, for the form translated easily to the monuments of the spiritual. The designers of churches recognized that the glory of something greater than ourselves deserved fantastical ornament, ostentation that must be bestowed on that which cannot fully be understood. And so Minnesota archbishop John Ireland commissioned French architect Emmanuel Masqueray to design a Catholic cathedral on the highest point in St. Paul. Masqueray, who had studied at the Paris institution, designed a breathtaking

church that reached skyward, towering over all about it. The striking envelope housing the cathedra of the Catholic Church in Minnesota was intended as an accent to the stunning Minnesota State Capitol Gilbert was erecting just to the north. Work on the cathedral began as that on Gilbert's building was finishing, and while their Beaux-Arts architectural elements are similar, their forms contrast: the capitol's long horizontal massing and rigidly regular fenestration voice the civic, while the cathedral's upward thrust to the heavens trumpets the spiritual.

Gilbert and Masqueray were architectural kindred spirits, but not all American architects at the beginning of the twentieth century were charmed by classicism. Indeed, an entire school of architectural thought grew up around Chicago and became commonly known as the Chicago School. These designers were put off by traditionalism. Led by Frank Lloyd Wright, architects such as William G. Purcell, George G. Elmslie, George W. Maher, Marion Mahony, and Walter Burley Griffin set about altering the classical themes of cities, to some degree shaping buildings as an extension of the midwestern prairie. Some of the buildings designed by these individuals were striking, but the Prairie School style never entirely washed away traditionalism, in part because the traditional aesthetic translated so well to civic places. Generations of Americans, descended from European immigrants and educated in European traditions, clung tightly to classicism in public architecture, even as that classicism increasingly was abstracted, morphing into what we ultimately came to understand as Art Deco and Moderne. Nevertheless, Wright and his adherents produced wildly imaginative works of art within which the public existed from day to day, including Wright's own Solomon R. Guggenheim Museum in New York, which Wright designed in his later years and was anything but Prairie style—it was a geometric symphony, an aesthetic unto itself, although Wright ensured it was absent any hint of classicism.

CASS GILBERT

Gilbert was a transplant from Ohio. Born in Zanesville in 1859, Gilbert moved to St. Paul with his family when he was nine years old. He began working as a draftsman in 1876, soon concluding architecture would be his vocation. Two years later, he was studying in an architecture program at the Massachusetts Institute of Technology (MIT), the only school in the country at that time specifically offering a formal training curriculum in architecture. He interrupted his schooling a year later to journey about Europe, specifically England, France, and Italy.

In a work on the architect's early years, Geoffrey Blodgett provides a brief yet fascinating history of Gilbert's time abroad as a young man. By the late nineteenth century, Americans increasingly were traveling to Europe, inspired to a large degree by Baedeker guides. Not all could, of course, but for social climbers like Gilbert, experiencing Europe, which was widely viewed as more cultivated than America, was a means of pondering the wonders of the European mind while also padding one's social résumé in an effort to make the climb quicker and easier. Indeed, Gilbert's aspirations almost demanded that he journey overseas.

Initially, the young Gilbert was anything but impressed with England. The seepy and smoky atmospherics of industrial London made him rasp and sneeze, while also denying him the simple pleasure of scrutinizing the built artistry he longed to see. That which he could observe did not greatly impress the twenty-year-old Gilbert. He ravaged the work of Sir Christopher Wren, explaining that the majesty of St. Paul's Cathedral merely was a product of its size. Blodgett implies that when Gilbert addressed the English architect's seventeenth-century Renaissance efforts in London, he did so somewhat snobbishly: "I haven't the slightest admiration for it," Gilbert remarked. But wisdom is the gift of maturity and experience, and in time Gilbert cherished the audacity and ingenuity of Wren's designs. Later in life, as Gilbert addressed the College of William and Mary in Virginia, an academic institution for which Wren drew original plans, he said: "Wren was a bold designer and a daring constructor. Inventive and ingenious, he dared follow where his logic led, and to build according to his own invention with unfailing confidence in the practical value of his Science and Knowledge." Gilbert was nearing his mid-sixties by the time he penned those words, no longer a youthful snark but a wizened admirer.

The young Cass Gilbert, 1880.

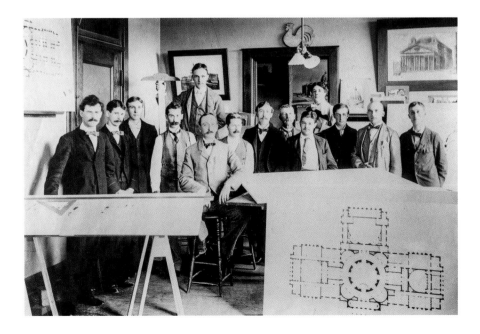

Gilbert (seated at middle) and his architectural staff during the construction of the capitol, about 1900.

Young Gilbert was not enthralled with England, but he was enamored by France, especially Paris. He roomed in the Latin Quarter and mingled with young Americans near the École des Beaux-Arts, which he toured; he frequently discussed with others its design philosophies. Although he longed to be schooled at the institution, life carried him in another direction. He traipsed about the city completing watercolors and pen and ink sketches, awed by the grandeur of the Cathedral of Notre Dame, the Louvre, and other landmarks. He moved on to other parts of France and Italy, enormously impressed by the architectural lavishness he often encountered, as well as the architectural surreality he occasionally discovered, such as the agitated yet visually balanced roofline of the Château Chambord in France's Loire Valley. All too soon he was forced to return to America, his funds exhausted. The trip made a profound impression, however, and his subsequent work was forever influenced by the aesthetic spectacle he witnessed across the Atlantic. He would travel to Europe again, for here he continually found inspiration for his own architectural efforts.

After Gilbert returned to America, he was hired in 1880 as a draftsman for the prominent New York architectural firm McKim, Mead and White. He worked with the firm for a few years, returning to St. Paul in 1883 to attend to family concerns. One year later, he partnered with James Knox Taylor, who was a boyhood friend and MIT classmate. Gilbert completed most of the design work for the St. Paul architectural enterprise, while Taylor largely handled the business issues. The partnership lasted until 1891, when Taylor left for Philadelphia. Primarily, the firm's commissions consisted of residences and churches, although the duo completed designs for commercial buildings as well. One of the firm's notable commercial designs was the Endicott Building in downtown St. Paul. Gilbert considered the building, completed in 1889, to be one of his major Minnesota commissions. The six-story L-shaped stone and brick edifice fronts both Robert and Fourth Streets, although the face of the former is more elaborate than that of the latter, resembling a kind of "Renaissance Italian Palazzo," according to its National Register nomination. Gilbert had an office in the building.

After Taylor departed, Gilbert worked alone for a number of years. In 1887, he married Julia Tappan Finch, an acquaintance of several years and the daughter of well-heeled local attorney Henry Martyn Finch. The couple had four children, although daughter Elizabeth died of meningitis in 1904 at age fourteen. While practicing by himself, Gilbert completed designs for warehouses, small commercial buildings, and residences. Benefiting from the elevated social circles within which he moved, he gained commissions from railroading industrialists like James J. Hill. He designed a number of buildings for rail lines, including the attractive Northern Pacific Railway Depot in Little Falls, a Craftsman-style building that is one of the most architecturally pleasing railroad depots in the state. It was finished in 1899, while Gilbert was still engaged with the Minnesota State Capitol.

MINNESOTA'S STATE CAPITOL

In 1994, writer Thomas O'Sullivan made plain the significance of Minnesota's state capitol:

> The Minnesota State Capitol stands at the intersection of high ideals and everyday life. It is home to lofty discourse and petty arguments, graceful allegorical paintings and tons of mundane paperwork. A statehouse has functional *and* symbolic duties. It needs sufficient size and working space to accommodate the branches of state government. But a statehouse is more than square footage. It is the heart of civic life, and deserves a grandeur of expression that Minnesota's Capitol delivers in design, decoration, and craftsmanship. Its noble spaces and fine materials are reminders to anyone who enters—whether senator or schoolchild—that this is a special place for important business.

Gilbert was not daunted by his responsibilities in creating such a unique place. The project was immensely complex, and yet the architect welcomed control of virtually every aspect of its construction. Even so, he relied heavily on Seabury's ability to clear a path for his vision.

Work quickly commenced. George J. Grant of St. Paul had received the commission for the grading, excavation, and foundation in late April 1896, and by early December this work was finished. A couple of days later, the Universal Construction Company of Chicago, Illinois, commenced structural metalwork for the basement. After only a month, the task was complete. All of this work was done quickly and below cost estimates, and yet construction stopped because funding available through 1897 was exhausted.

Gilbert and Seabury understood construction could not continue in this manner. Modest appropriations in a piecemeal fashion guaranteed an exceptionally long project. Moreover, cost for materials and labor were relatively low at this point, and without adequate funding, contracts guaranteeing the lower costs were not let.

Seabury asked Gilbert to document all that could be accomplished if the project were regularly and appropriately funded. Gilbert produced a detailed study for the Board of State Capitol Commissioners' vice president to offer the state legislature. Seabury, in turn, employed the opinions of architects Harry Wild Jones and J. W. Stevens to further spur legislative action. Believing the old capitol a fire hazard, both architects stressed the need to quickly complete the new one; the memory of the capitol fire just sixteen years earlier must have been a powerful motivator. Stevens explained: "While fire is liable at

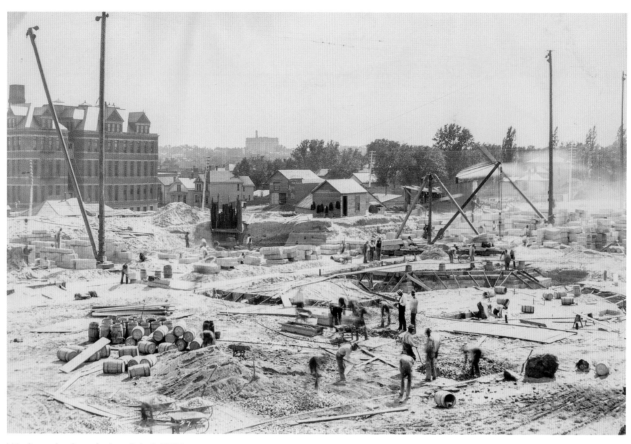

Work on the foundation, July 1, 1896.

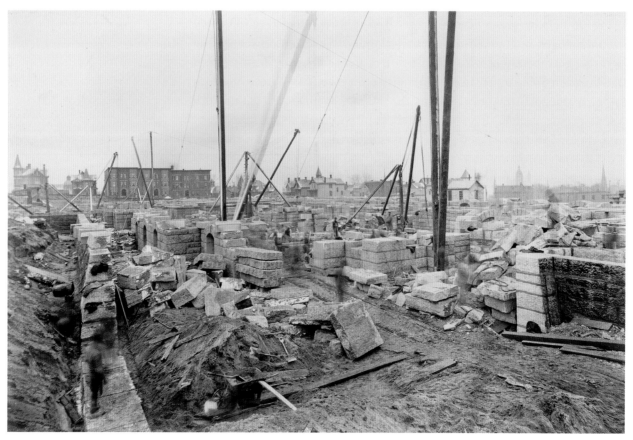

The foundation rises, October 31, 1896.

any time, it may never occur, but, if once started, I am of the opinion that it would be difficult, if not impossible, to save the building from total destruction." Jones was more dire: "My observation of its present condition, together with my knowledge of its mode of construction, has led me to believe for some time that the life of the officials, and public property, is being seriously jeopardized." The governor's secretary, Tams Bixby, lent his voice as well, complaining that lack of office and secure space in the earlier statehouse was a substantial problem that must be overcome as quickly as possible. These and other voices of alarm produced the desired effect on the legislature, which authorized the Board of State Capitol Commissioners to issue up to $500,000 of certificates of indebtedness to complete the building. (The 1882 capitol proved inadequate for legislative purposes, but it nonetheless served the needs of others for another half century. It was razed in 1937.)

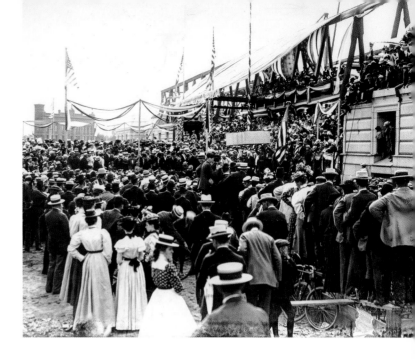

Laying the cornerstone, July 27, 1898.

Much of the 1897 construction season was lost in the delay in getting the necessary appropriation. And yet the winter of 1897–98 was remarkably warm, and Butler-Ryan, the contractor for the building's superstructure, completed considerable work. The official cornerstone ceremony was held on July 27, 1898, with many dignitaries in attendance. It was an impressive event, featuring military units, the St. Paul Mounted Police, and the Old Settlers' Association, a fraternal group recalling Minnesota's early frontier period. Eighty-three-year-old former territorial governor Alexander Ramsey, with a silver trowel in hand, laid a dash of mortar upon which was set the hollow cornerstone encapsulating a copper box holding forty-five books, documents, photographs, newspapers, and other articles intended to represent the state up to that period.

Like most of the superstructure, the cornerstone was of Georgia marble, a material that generated considerable angst. The building was to be Minnesota's face to the world, and unsurprisingly, many believed it should be a northern, native one, not a southern, foreign one. Moreover, considerable work would be generated in Minnesota if the stone were harvested and carved here. Some also continued to begrudge the South the turmoil of the Civil War; much of the generation that lived through that conflict was still alive. Gilbert, however, was convinced that the light-colored stone from Georgia was the best fit. Nonetheless, during 1897, much analysis and discussion went into the final decision on the stone. The commissioners voted on three proposals: a building entirely enveloped in Georgia marble, one clad in St. Cloud granite, and a third with a basement of St. Cloud granite and a superstructure of Georgia marble, with Kettle River sandstone providing the foundation and piers for the dome. The latter was adopted, but the decision split the board, creating lingering animosity.

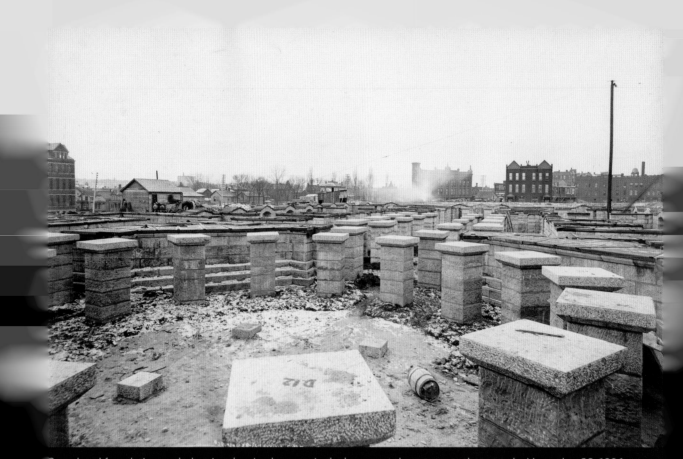

Completed foundation work showing the circular room in the basement that supports the rotunda, November 28, 1896.

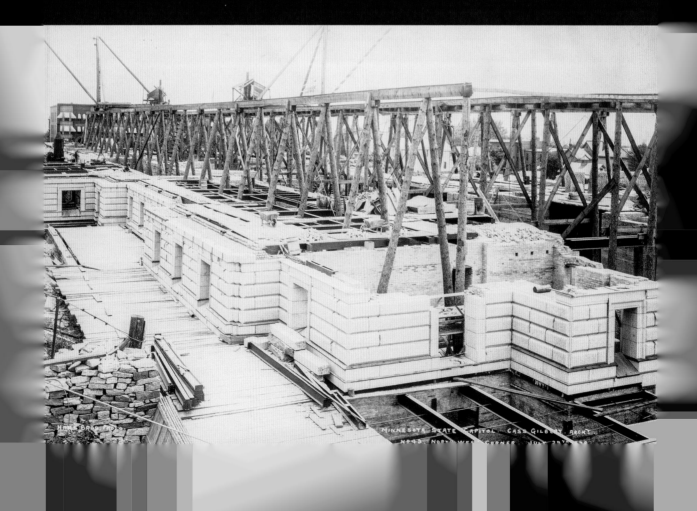

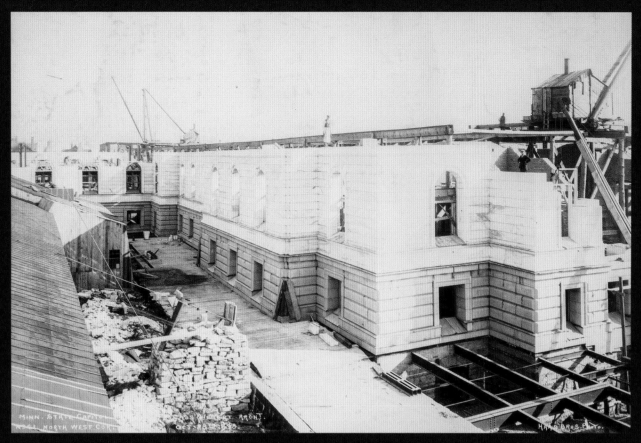

Marble tops granite, September 2, 1898.

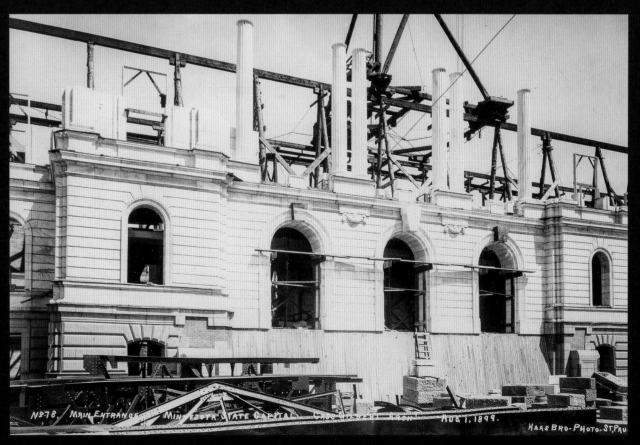

Columns rise above the south entrance, August 1, 1899.

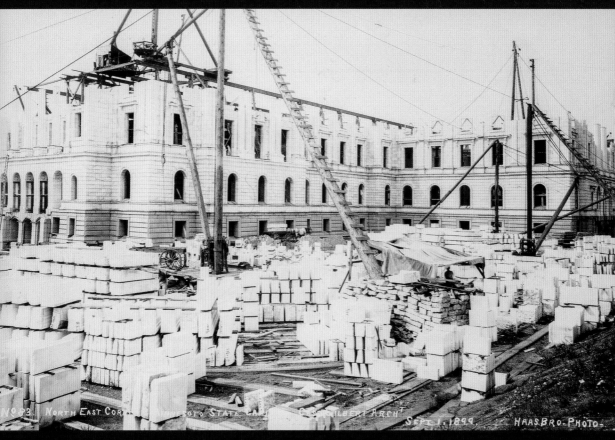

Stones await placement, September 1, 1899.

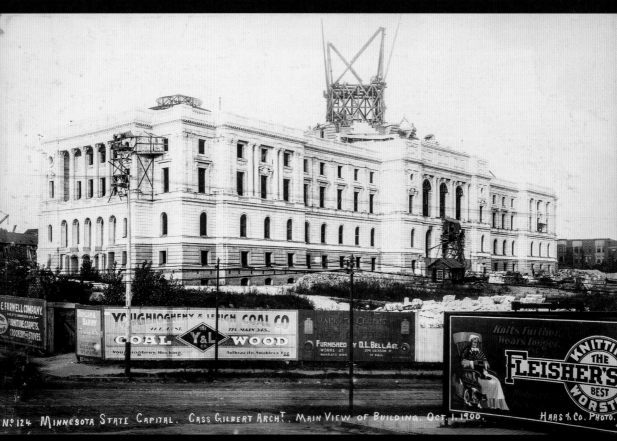

Construction of the dome, October 1, 1900.

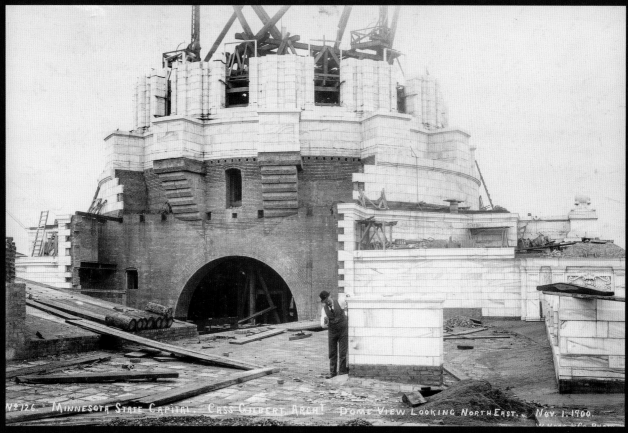

Dome construction, November 1, 1900.

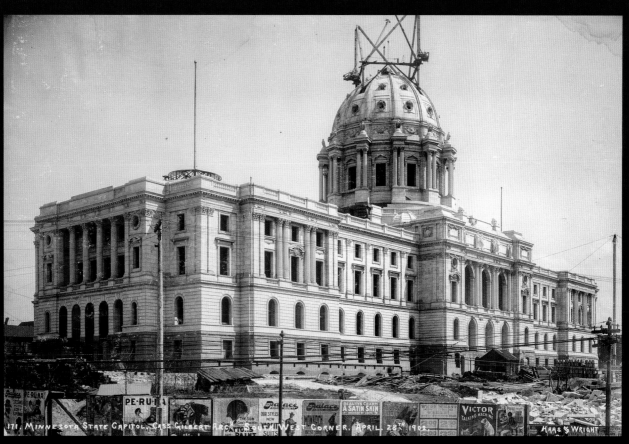

Nearing completion of the exterior, April 28, 1902.

Gilbert's vision won out, thanks in large measure to his champion on the board, Seabury. However, the vice president and the others who had voted for a building largely of nonnative stone were being practical as well. Granite is harder than marble, and so more costly to harvest, dress, and lay. The coloring of St. Cloud granite also is rather somber, and Gilbert and others believed the lighter hue of Georgia marble was aesthetically better suited to such a large and long state capitol. To some degree, those desiring the Georgia marble had mollified critics by promising not only to use local granite at the ground floor but also to make over the interior with considerable Minnesota stone. An additional commitment to carve and dress all of the marble in Minnesota sweetened the promise.

Late in the year, Gilbert set off for Europe on a fact-finding mission, learning more about mechanical systems and other building technologies. As always, he pondered the fine art so prevalent in the major cities of Europe and contemplated how to employ such decoration in Minnesota's capitol. When he returned, he had the heating and electrical plant constructed a short distance

The crew at Biesanz quarry in Winona that quarried the limestone used in the capitol's foundation, ca. 1900.

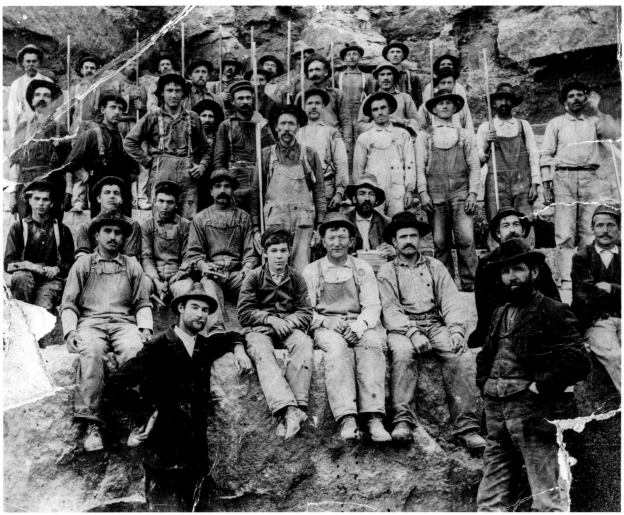

east of the capitol. Like the statehouse, the plant embraced classicism, but it was more subdued. Today, the plant's original architecture is mostly apparent, but, regrettably, the east side and north rear have been marred by goiterous additions.

The exterior of the capitol was almost complete by 1900, although the dome still had to be erected. It was a separate contract, but Butler Brothers Construction Company, successor to Butler-Ryan, nevertheless won the commission. With erection of the dome in 1902, the exterior was largely complete. Only the stairs at the east and west ends remained, and they were finished sometime between 1905 and 1907, after the building had opened.

Attired in the creamy polychromatic swirl of Georgia marble, the four-story building paid overt deference to the Renaissance palazzo. With a steel and cast-iron frame set atop a limestone foundation anchored by concrete footings, the expansive building exhibited the rigid symmetry common to

civic architectural statements; besides the ordered fenestration, the loggias at the east and west ends were identical. The building was festooned with all manner of classical embellishment, including actual festoons, all lying upon its tripartite form like sugary confections. Above the main entry, between fluted columns with ornate capitals, nestled immense Roman arches accented with scrolled keystones. Six sculpted figures symbolic of humankind's better qualities adorned the entablature over the loggia, upon which gleamed the quadriga of golden horses *The Progress of the State*, a magnificent sculpture by Daniel Chester French and Edward C. Potter. To the left and right, balustrades defined the length of the roofline. From the oblique perspective of the quadriga, the richly ornamented dome was reminiscent of a bejeweled papal tiara. Paired Corinthian columns encircled the dome, supporting a cornice bearing raptors, while window openings featured pediments and scrolled hoods framed within recessed panels parceled by the dome's vertical ribbing. The final garnish was a lantern with shining, globed finial.

A detail of Gilbert's proposed design for the capitol, 1895. The most obvious change in the finished building is the use of an arcade at the loggia, rather than merely columns. Labels and a detail are added to identify several aspects of Beaux-Arts design for modern readers.

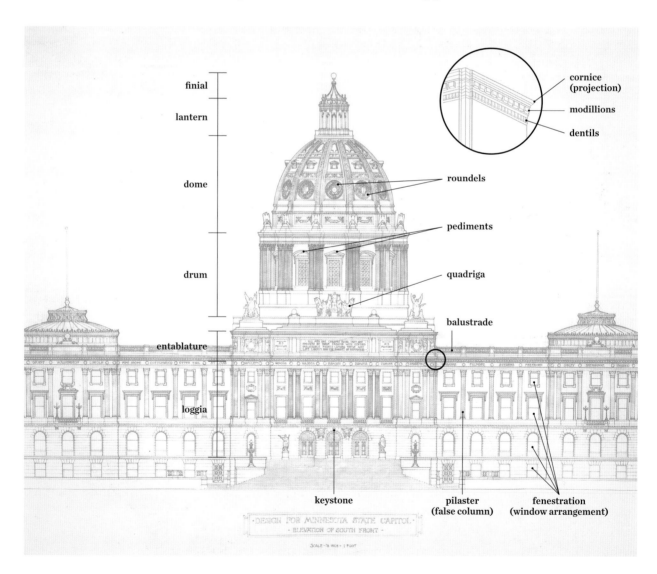

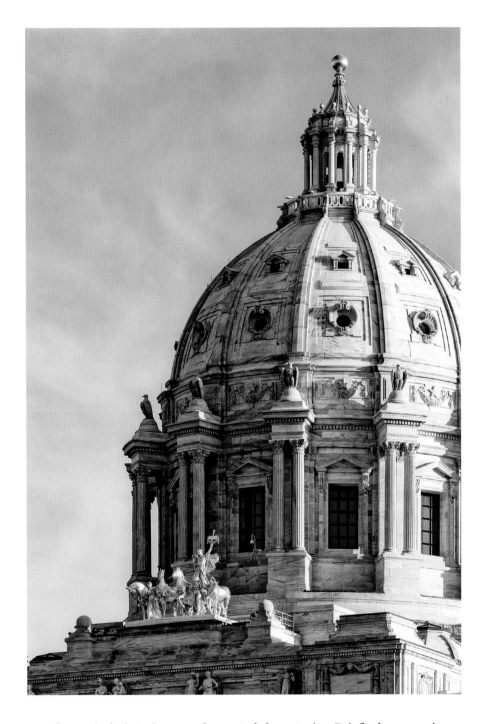

The Progress of the State, the magnificent quadriga by Daniel Chester French and Edward C. Potter, sits at the base of the capitol's dome. This photograph, taken in 2009, shows the discoloration of the marble before it was cleaned in the restoration.

The capitol's interior complemented the exterior. Briefly, however, it appeared that this may not be so. In 1901, as work on the exterior progressed, funds diminished quickly. This resulted in part from an economy that had thoroughly rebounded from the depression that began in 1893. Material and labor costs had increased considerably from 1896, the year capitol construction commenced and initial contracts were let. With inadequate funding, Gilbert and the commissioners feared that the capitol's inviting exterior may ultimately belie a vulgar interior. In truth, however, no one desired a mimic

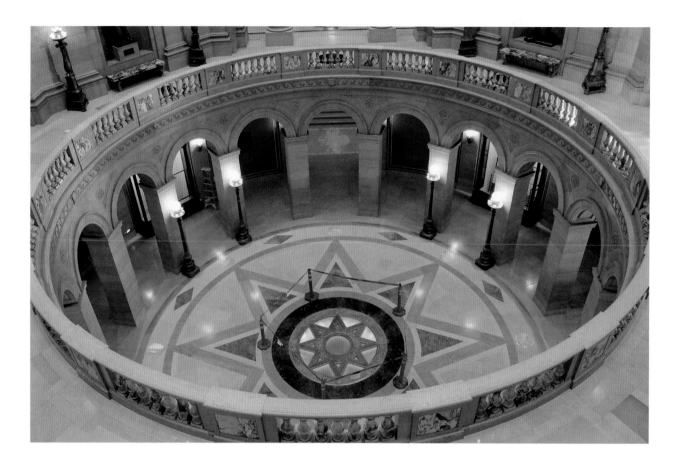

The floor of the rotunda.

of tangible cosmopolitanism; all understood the genuine article demanded that the interior complete the expression. Legislators authorized an increase of $1.05 million, and yet this, too, proved insufficient to finish the building. In early 1903, the commissioners again approached state legislators, and again additional funding was authorized, this time in the amount of $1.5 million. It would be the final appropriation, but acquiring additional public dollars after cost overruns is politically toxic. Seabury and the other commissioners deserve credit for their tact and powers of persuasion.

It was costly but worth it, for the capitol interior was even more classically exuberant than the exterior. Here also were columns, arches, entablatures, piers, balustrades, and so much more, all finely detailed. Rich earth tones accented in gold warmed public spaces. Above, inside the rotunda and dome, were rich shades of blue, a contrast making plain Gilbert's desire to evoke earth and sky. A brass North Star embedded in glass was centered within the rotunda floor, with each two adjacent starbursts shaping the letter "M," for Minnesota. The design was repeated in stone in the surrounding floor. The vaulted ceilings of the first-floor corridors were splashed with hand-painted arabesques of Minnesota fruit, grain, and flora. Elaborate and colorful murals embellished walls, providing allegorical illustration of Minnesota's evolution. Paintings hung in the governor's reception room, an ornately decorated space of white oak with plaster of paris emblems of the state accentuated with gold leaf.

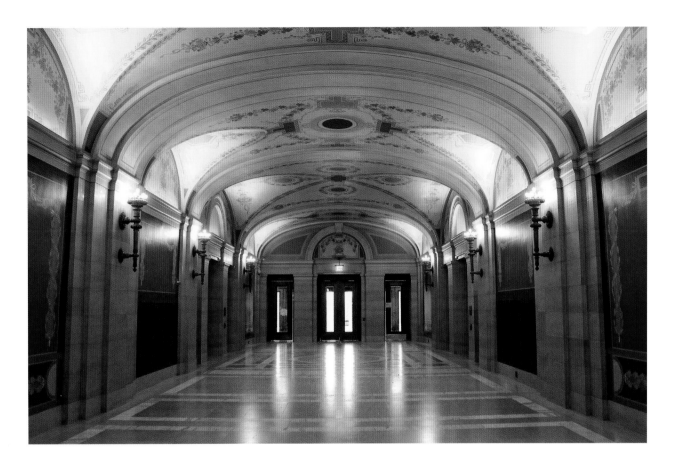

East corridor, first floor.

Gilbert adopted a wide variety of marbles for the interior, both foreign and domestic. The white-gray shading of Vermont marble accented parts of the House and Supreme Court chambers, while marble in the Senate chamber was a mottled violet and white Fleur de Peche (France). The walls in the first- and second-floor rotunda and corridors were faced with the earthy hues of polished Kasota and Mankato limestone trimmed with a red border of Sioux quartzite. The second-floor railing was of tan-colored Hauteville marble (France) with balusters of Skyros marble (Greece), an attractive off-white stone with multicolored veins. The handsome grand staircases to the east and west also were composed of Hauteville marble with Skyros-marble balustrades. Fanciful oval pendants of Breche Violette marble (Italy), similar in color to Fleur de Peche, and yellowish Old Convent Siena marble (Italy) punctuated spandrels between arched openings at the first floor at either side of the ascending staircases. The ovals were framed with carvings of polished Kasota limestone.

The pairs of columns at the north and south sides of the second-floor rotunda were composed of lavender-shaded Ortonville granite, while the pairs at the east and west were made of cloudy-colored St. Cloud granite. The thirty-six columns edging the east and west stair corridors were Breche Violette, while door and window casings exhibited mottled Echaillon marble (France). The polished floor was dominated by a mix of Joliet stone and Tennessee marble accented with other marbles, including dark red African Numidian.

An Ortonville granite column being placed on the north side of the rotunda, April 4, 1904.

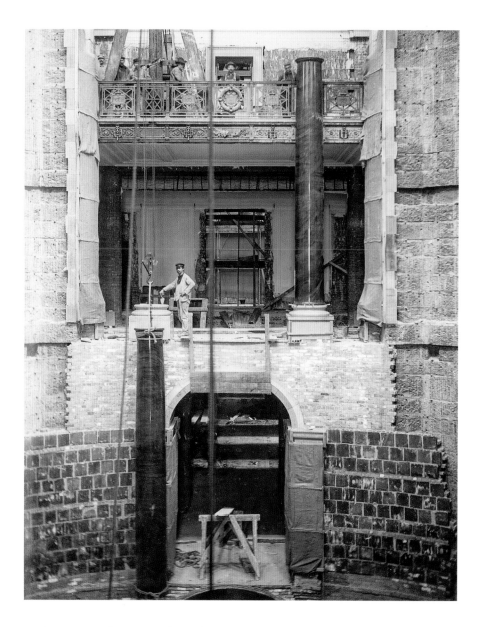

Encompassing approximately 380,000 square feet, the capitol housed the executive, judicial, and legislative branches of government, with the interior parceled into numerous spaces for the various leaders and support staff necessary to manage a sovereign state. However, considerable public space was available in the corridors and especially near the central portion, in and around the rotunda, principally on the first and second floors. On the third floor, less centrally located but vital to the building's function, visitors accessed the various galleries to view the legislative process. The Minnesota Historical Society dominated the east wing of the ground floor, with stack rooms at either side of the wing. The reading room itself was immediately west of the newspaper stacks at the wing's north side. The public library commissioner had an office in the northeast corner. Additional public spaces were available at this level as well. A persistent belief is that when the capitol opened, no

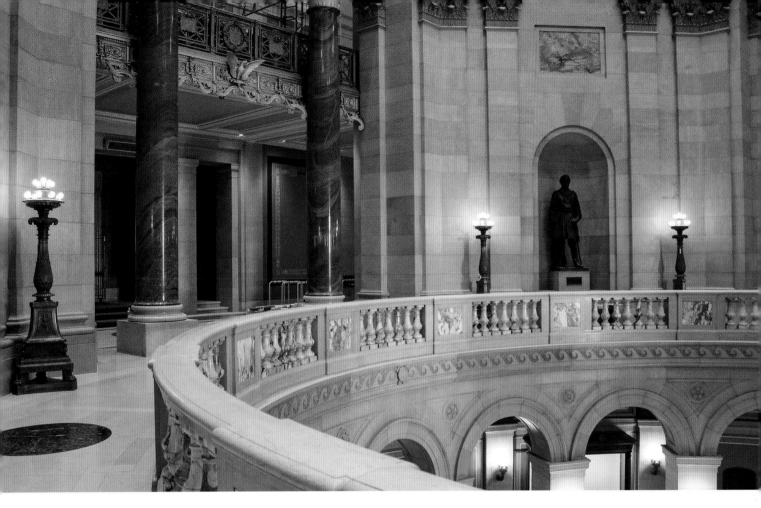

The columns in place, over a century later.

accommodation was available for women. This is an odd notion, especially since the capitol is a public building. Moreover, roughly 25 percent of those working in the capitol at the time were women. A women's restroom, next to the "Ladies' Waiting Room," graced the north corridor.

The governor's suite of offices was set on the first floor's west wing, with the exceptionally ornate governor's reception room filling a substantial area in the southwest corner of the wing. The wing's southeast section was occupied by the secretary of state, while the northwest section hosted the attorney general. The northeast section was filled by the insurance commissioner. The first floor's east wing held offices for the treasurer, auditor, railroad commissioner, and their respective support staff. The public examiner and adjutant general were housed in the north wing.

On the second floor, the Senate chamber and its retiring room occupied much of the west wing, while the House chamber and its adjacent retiring room were in the north wing. The Supreme Court chamber and consultation room were set in the east wing. Spaces for House and Senate leaders, as well as various committees, filled much of the remaining area in the north and west wings. The office of the lieutenant governor, who was the presiding officer in the Senate, was placed in the southwest corner of the west wing. Supreme Court justices each had a private room in the east wing. Nearby spaces housed legal resources; the law library and reading room dominated the north side of the east wing.

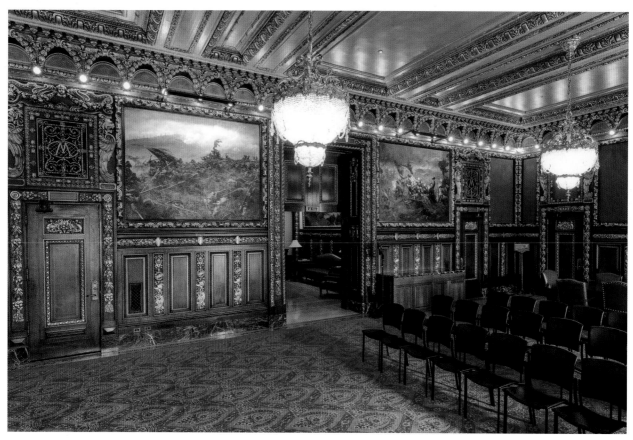

The governor's reception room.

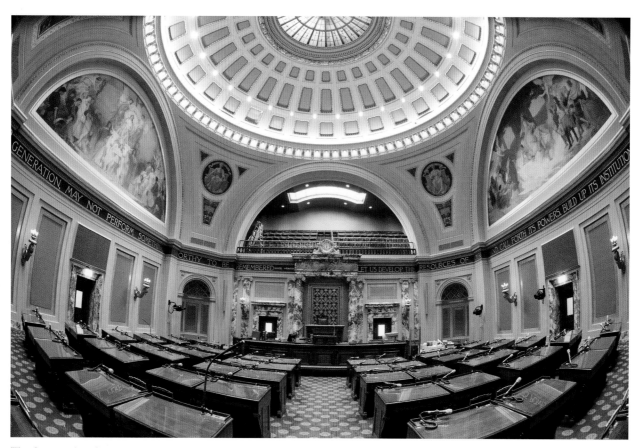

The Senate chamber.

The west wing of the third floor held many House and Senate committee rooms. It even had space for representatives of the Grand Army of the Republic, further evidence of how the memory of the Civil War continued to influence the state psyche as Minnesota stepped into the twentieth century. Numerous others had offices in the capitol as well, including the board of health, livestock sanitation board, board of control, labor commissioner, dairy and food commissioner, secretary of the Soldier's Home, superintendent of public instruction, game and fish commissioner, and boiler and oil inspectors. It is difficult to imagine today, with state agencies scattered all across St. Paul, but when the capitol was constructed, it housed virtually every state office.

The Rathskeller and the cantilevered staircase were two of the most distinctive features inside the capitol. The Rathskeller was based on the German practice of a city hall (*rathaus*) with a restaurant in its basement (*keller*). In keeping with German tradition, the Rathskeller's earth-toned walls and ceiling were decorated with murals and painted mottos in German. Fanciful hand-painted stenciling accented the vaults that shaped the ceiling, with some vaults punctuated by a raptor design reflective of German tradition that nonetheless was garbed in American colors. All of the artwork, including mottos, was painted over because of pressure from Prohibitionists and anti-German sentiment during the First World War. It was not fully restored until the 1990s, in a painstaking effort that included removal of twenty-two layers of paint.

Gilbert's oval cantilevered staircase occupied the stairwell immediately northeast of the rotunda. To a layperson, the staircase may appear merely handsome. It is, however, an engineering feat unique for turn-of-the-twentieth-century Minnesota. Each section of staircase is supported only on one side; it is cantilevered, projecting from the wall, within which is a vertical support. In essence, the stairs hang from the wall, not unlike a shelf.

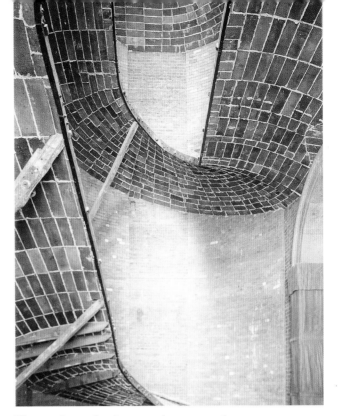

The cantilevered staircase under construction, February 26, 1904 (see p. ii).

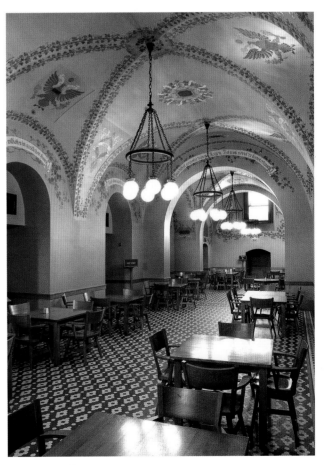

The Rathskeller.

CAPITOL ART

The interior of the capitol, like the exterior, was a work of architectural art, but Gilbert wished also to complement it with fine art. He made clear his desires to the Board of State Capitol Commissioners: "Nothing will give the building greater distinction or lend more to its educational value and to the evidence of the advancement of civilization and intelligence of the State than the recognition of the arts as represented by the great painters and sculptors of the present day, and I unhesitatingly and strongly recommend that ample provision be made to decorate the building with mural painting and sculpture."

Gilbert sought out many of the finest artists of the period, such as Kenyon Cox, Arthur Willett, Elmer Garnsey, Edwin Howland Blashfield, Henry Oliver Walker, Edward Emerson Simmons, John La Farge, Douglas Volk, Francis D. Millet, Howard Pyle, and Rufus Fairchild Zogbaum.

At the time the capitol opened, it contained roughly sixty works of art, totaling about $300,000, or 7 percent of the $4.5 million project budget. In time, the number of artworks would grow to roughly 150. Much of the art was allegorical, as expressed through murals, and in their names and content they reflect the perspectives of their time. Edward Simmons completed his four-panel set *Civilization of the Northwest* on the rotunda walls. In romantic fashion, it illustrates the narrative of Minnesota's evolution to prominence and sophistication. In the final panel, for instance, the protagonist demands that the four female figures symbolic of the four winds depart to the corners of the globe carrying the largesse of Minnesota, as well as its knowledge and word of its growing cultural sophistication. Kenyon Cox's *Contemplative Spirit of the East,* placed within the east grand staircase, interprets the East as a refuge of stability and contemplation, which is a contrast to the West, a land of activeness and advancement. The six lunettes below the skylight on either side of the east grand staircase illustrate the activity and industriousness of turn-of-the-twentieth-century Minnesota, and include images reflecting *Commerce, Winnowing, Stonecutting, Navigation, Mining,* and *Milling.*

The west grand staircase hosts Henry Walker's marvelous *The Sacred Flame (Yesterday, Today and Tomorrow).* An elderly woman at right maintains the fire, while the central female figure holds out a torch to the lamp held by a youthful woman at left. In essence, the flame is being transferred from past to present to future, although what the flame represents is left open ended, since Walker suggested it could be Knowledge, Thought, Civilization, or Being itself. As at the east grand staircase, the west grand staircase is edged by six lunettes. Again, the lunettes represent aspects of Minnesota's development. The images are *The Logger, Horticulture, Huntress, Pioneer, Sowing,* and *Dairy.*

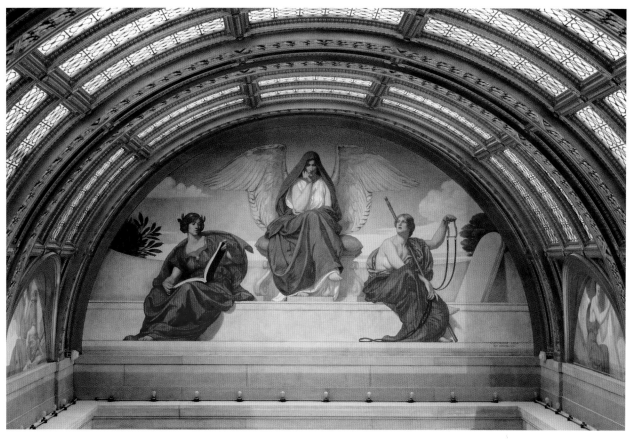

Contemplative Spirit of the East, painted by Kenyon Cox, hangs over the east grand staircase.

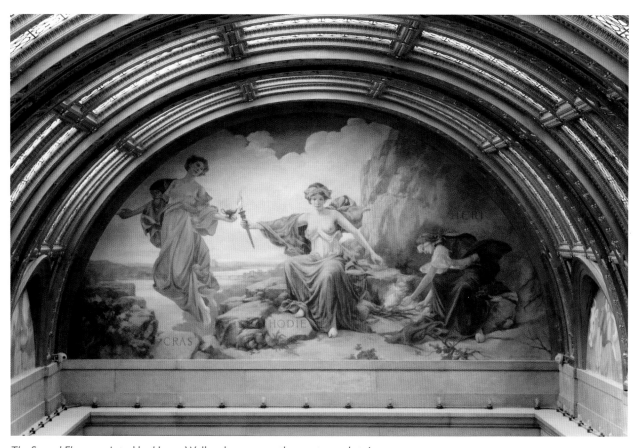

The Sacred Flame, painted by Henry Walker, hangs over the west grand staircase.

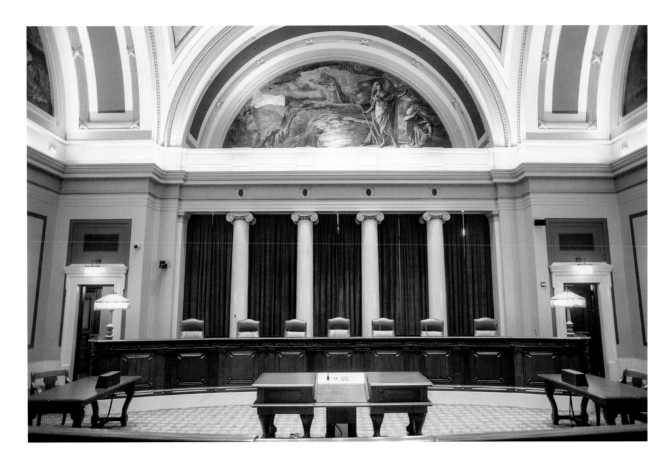

La Farge's *Moral and Divine Law* hangs above the Minnesota Supreme Court's bench.

John La Farge finished the four murals in the Supreme Court chamber. *Moral and Divine Law*, on the east wall, shows Moses receiving the Law. Joshua extends his left arm in warning to those who may approach, while Aaron is supplicated in awe and fear. In *The Recording of the Precedents*, on the north wall, Confucius sits near a river with three disciples pondering his annotation to a manuscript spread over his lap. The south wall holds *The Adjustment of Conflicting Interests*, an image of Count Raymond of Toulouse mediating between officials of the Catholic Church and local leaders. Lastly, *The Relation of the Individual to the State* is on the west wall. La Farge explained that the mural depicts Socrates conversing with men of a wealthy family, while the sophist Thrasymachus attentively listens. The artist further adds that Socrates perhaps is pontificating that "the true artist in proceeding according to his art does not do the best for himself, nor consult his own interest, but that of his subject."

Edwin Blashfield composed *Minnesota: Granary of the World* and *Discoverers and Civilizers Led to the Source of the Mississippi,* both inside the Senate chamber. The former shows Minnesota as breadbasket, a leader in agriculture, but the soldiers in the image also reflect the state's contribution to preserving the Union. Blashfield honored both Gilbert and Seabury by painting their likenesses at the left edge of the lunette, adjacent to the leg of the figure representing Agriculture. A northern Minnesota forest is the backdrop for *Discoverers*

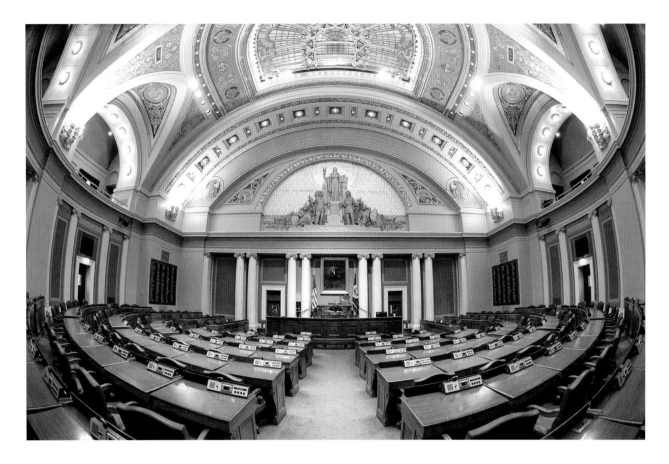

and Civilizers, among the most explicitly Euro-centric paintings in the capitol. Manitou or Great Spirit begins the flow of the Mississippi River by pouring water from an urn. It is a romanticized depiction of American Indians that minimalizes their contributions to Minnesota history.

The House chamber offers an ornate plaster relief above and behind the Speaker's rostrum, although this relief was not completed until 1938. It filled a former public gallery space. Composed by Brioshi Studios, it is titled *Minnesota, the Spirit of Government.* The artwork features the North Star and other figures, including native peoples and explorers. Its inscription notes, "The trail of the pioneer bore the footsteps of liberty," which Thomas O'Sullivan suggests is "a ringing non-sequitur." The wall behind the sculpture reads, "Vox populorum est vox Dei," or "The voice of the people is the voice of God." It is perhaps a reminder to lawmakers of the impact of their decisions on those who raised them to prominence.

Additional paintings included the twelve zodiac lunettes decorating the interior of the dome. All were painted by Elmer Garnsey and his assistant

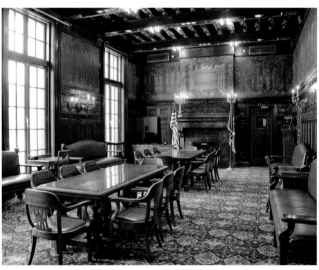

TOP: The House chamber.
ABOVE: A frieze designed by Elmer Garnsey, depicting Minnesota trees and flowers, covers the walls in the House retiring room.

Arthur Willett, the same artists who composed the murals at either side of the east and west grand staircases. Douglas Volk is responsible for *Father Hennepin at the Falls of St. Anthony*, and Francis D. Millet composed *The Treaty of Traverse des Sioux,* each in the governor's reception room, but at opposing ends. Both are easel paintings that were designed to fit within decorative niches that specifically form part of the architecture of the room. Six Civil War paintings were commissioned for this space and the adjacent anteroom. Four of these also fill niches that are a part of the architecture of the space, while two are framed artworks set in the anteroom.

CAPITOL AS CIVIL WAR MONUMENT

While the capitol is chiefly a monument to the people of Minnesota, the Civil War paintings help drive the narrative that the capitol is a monument to Civil War veterans. In some ways, this association may be inevitable. The war had a genuinely traumatic impact on the state's development and was still much in the minds of its citizens just thirty-some years later. Many of the legislators voting for appropriations to construct the capitol were veterans of that war; roughly twenty-five thousand Minnesotans had served, and a significant number of them, mostly in their fifties and sixties, were still living. Certainly, the transfer of the various regimental battle flags in 1905 from the old statehouse to the new showed a desire to memorialize the veterans in the capitol. Telling the state's history thus required that the war and its sacrifices be strongly featured.

Other features in the building support this implication. The second-floor rotunda has four statues, all of men who fought in the war: William Colvill, Alexander Wilkin, John B. Sanborn, and James Shields. A plaque dedicated to the First Minnesota is in the rotunda on the first floor. The six paintings depicting scenes from the Civil War in the governor's reception room include Francis D. Millet's *The Fourth Minnesota Entering Vicksburg* (ca. 1904) and Douglas Volk's *The Second Minnesota Regiment at Missionary Ridge* (ca. 1906). Rufus F. Zogbaum composed *The Battle of Gettysburg* (ca. 1906), which illustrates the First Minnesota's charge down Cemetery Ridge led by Colonel William Colvill. *The Battle of Nashville* (ca. 1906), showing the Fifth, Seventh, Ninth, and Tenth Minnesota regiments in combat, was painted by Howard Pyle. All were installed in 1906 and 1907. Two additional works were completed and installed later: *The Third Minnesota Entering Little Rock* (ca. 1910), by Stanley M. Arthurs, and Edwin H. Blashfield's *The Fifth Minnesota at Corinth* (ca. 1912). One more Civil War painting was commissioned: *Eighth*

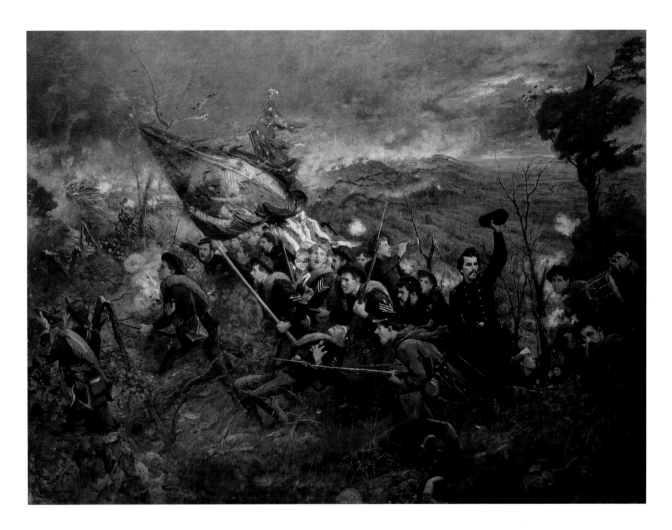

Minnesota at the Battle of Ta-Ha-Kouty (Killdeer Mountain) by Carl L. Boeckmann was hung in the House of Representatives chamber. It does not depict a Civil War event but an 1864 attack on a mostly Lakota encampment in what is now North Dakota; the regiment was part of a punitive expedition, and the painting would become controversial as viewers realized that the soldiers had attacked an encampment of families, defended by men who were mostly armed with bows and arrows.

Given the quality and quantity of Civil War art and artifacts in the capitol, it is easy to understand the notion of the capitol as monument to Civil War veterans. Still, the historical record suggests a less intentional and more evolutionary story. The reverential treatment of the regimental battle flags was traditional. It began in 1861, when the colors of the First Minnesota were displayed in the governor's office in the first capitol after the First Battle of Bull Run, a resounding defeat for federal troops but a moment of immense courage by the First Minnesota. The second capitol featured a specially designed display case to house the various flags. The concept of the statehouse as repository of the Civil War regimental battle flags carried over to the present capitol when they were transferred by the veterans on Flag Day in 1905.

Douglas Volk's *The Second Minnesota Regiment at Missionary Ridge,* painted about 1906.

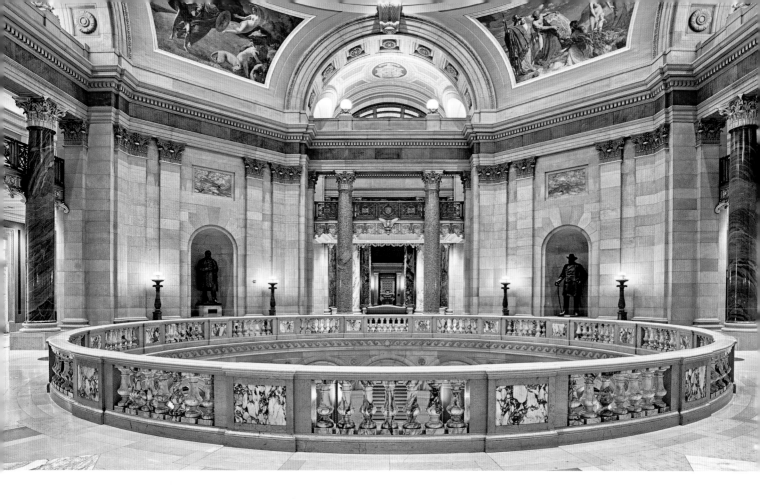

Looking west across the rotunda on the second floor, with statues of Civil War officers General John Sanborn and Colonel William Colvill, March 2017.

When Gilbert contemplated what art would decorate the interior of the building, he focused chiefly on allegorical murals to explain the history, prosperity, intellectual maturity, and nobility of the state. Additionally, it appears that he wished statuary of Minnesota senators or US presidents in the second-floor rotunda rather than Civil War veterans. In homage to veterans, Gilbert desired a large obelisk on the Capitol Mall, a display in plain view. However, as work on the interior art continued, the Board of State Capitol Commissioners was approached by legislators and veterans groups wishing art less allegorical and more reflective of real events in the state's past, including recognition of Minnesota's Civil War contingents. This influence, coupled with inadequate funding to erect the memorial in front of the capitol, convinced Gilbert to add Civil War tributes to the building's interior. However, the symbols of the veterans' sacrifice were added over a period of time, with some included well after Gilbert completed his task with the capitol.

Four of the Civil War paintings were included in the governor's reception room not long after the capitol opened. The others were finished several years later. The statues in the rotunda were installed between 1909 and 1914. Additional plaques and marble benches serving as memorials were added in the late 1920s and into the 1930s. While many of these additions postdated capitol construction, and Gilbert no longer had final word, he was frequently consulted on them. In any event, the Civil War memorials were added as products of lobbying by veterans groups and legislators; the broader tribute remains to the state and its people.

CAPITOL FURNISHINGS

The furniture within the capitol also is a part of the art. For the meticulous Gilbert, these pieces were yet another layer to the overall composition of the building. Many of these furnishings—principally those for public and ceremonial spaces—he designed himself, while other pieces were standard period designs.

Gilbert drew a dozen different types of chairs, including armchairs, easy chairs, swivel chairs, side chairs, and ceremonial chairs. The Senate and House retiring rooms featured relatively simple leather sofas and wood side chairs, although with cushioned seats upholstered in leather. In contrast, the ceremonial chairs for the Supreme Court chamber were ornate: revolving mahogany open armchairs with leather-covered padded arms, seats, and backs. Carved scrolling formed the top rail of each back. The armrests were scrolled as well, and the entire ensemble rested upon four slanted wood legs with claw feet and castors. The two ceremonial chairs for the presiding officer in the Senate and the speaker of the House were similar but even more fanciful, with wide top rails punctuated by a North Star crest framed by oak leaves. The French phrase *L'etoile du Nord* or "The Star of the North," Minnesota's motto, was prominently inscribed. Gilbert provided somewhat less regal swivel chairs for the governor's and lieutenant governor's offices.

Gilbert designed various armchairs and easy chairs—some modest yet handsome, their attractiveness found more in their lines than in adornment—including many created for the governor's suite of offices and the House and Senate retiring rooms. Others intended for the governor's reception room offered slightly more decoration. The Victorian wing chairs for the Senate retiring room, however, achieved a level of stylistic brashness, with ornate floral scrolling forming the stretcher between the front legs. Additional leather-upholstered easy chairs with tufted backs were created for the governor's reception room, lieutenant governor's office, Senate retiring room, and House chamber. Simpler designs were placed in minor corridors near the House chamber.

Gilbert also produced various plans for sofas that were crafted and placed in these rooms. As with the chairs, these were made of wood and typically upholstered in leather with brass tacks. Gilbert even designed a leather-covered chaise lounge with a large cylindrical headrest that was specifically requested by Supreme Court justices. Attractive settees for the use of visitors were placed in the first- and second-floor corridors, as well as in the Supreme Court chamber and House lobby. Formed of oak, all were liberally garnished with scrolling and other classical detailing, each essentially an aesthetic microcosm of the overall project. As with Gilbert's benches, some were of white oak but others

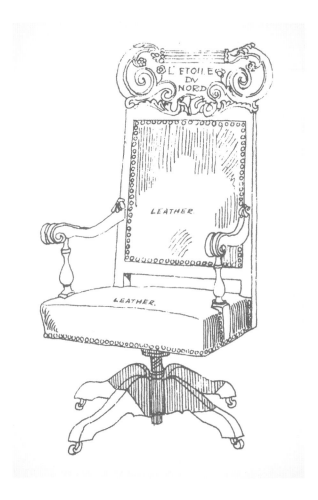

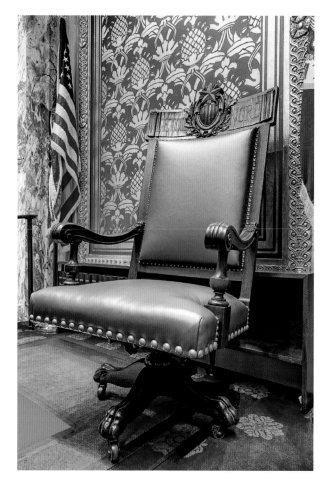

ABOVE: Cass Gilbert's preliminary sketch for the ceremonial chairs used in the House and the Senate.

ABOVE, RIGHT: The ceremonial chair used by the president of the Senate.

of Skyros marble. The four marble benches were for the second-floor rotunda, while the ten oak benches were placed in less prominent areas.

Several tables were designed, some for conference areas and others as work platforms. Those in ceremonial areas were artistic mahogany works, featuring various combinations of carved lion's heads, scrolling, acanthus motifs, and claw feet. The large conference table in the governor's reception room was the most ornate, with eight scrolled legs with acanthus carving. The bottom of each leg was a bun foot supporting a block with a finely carved rosette on each face. What truly set this table apart, however, was adoption of the inherently graceful oval for the tabletop, a shape further embellished with convex and inscribed edges. Gilbert designed many other worktables as well, including simpler pieces like drinking, messenger, and letterpress tables.

A capitol building requires numerous desks. The Senate and House chambers featured a total of 188 mahogany slant-top desks. The paneled façade of each was embraced by pilasters supporting mock entablatures. The opposite working side of the desk offered a wood top with underlying drawer, and below this was a half shelf and small cabinet with paneled door. Scrolling accented the rear edges of the desk's paneled sides. Many of the offices in the capitol featured mahogany or oak rolltop desks and double-pedestal desks, although

Senate retiring room, about 1905.

most of these were not designed by Gilbert but purchased. He also purchased several revolving bookcases. He designed the more than eighty classically inspired mahogany and oak wardrobes with paneled doors and bronze screens that were produced for various offices throughout the capitol.

Fabrication of virtually all of these furnishings was contracted to Herter Brothers and its subcontractors. Herter Brothers was a high-end New York furniture designer and manufacturer founded by German immigrant brothers in 1865. Its most prestigious commission was for the William H. Vanderbilt mansion in New York, work on which began in 1879. The company provided furniture for the New York State buildings at the 1893 Columbian Exposition in Chicago, as well as furniture for the Louisiana Purchase Exposition of 1904 in St. Louis, Missouri, but its fortunes were waning. The Minnesota State Capitol would be the last major commission of this once-prominent enterprise.

The restored Senate retiring room.

THE CAPITOL BUILDERS

A number of building firms, fascinating personalities, and pure talents worked on the Minnesota State Capitol, including experts in all manner of construction. Their stories are reminders of how building techniques have changed—and how the lives of individuals are connected to larger events.

The foundation was completed by local contractor George J. Grant, while the principal contract was awarded to the Butler-Ryan Company of St. Paul. Butler-Ryan was founded in 1886 by brothers William and Walter Butler, with the duo merging with Mike Ryan in 1894. Butler-Ryan was made up of expert builders, but the company had never before worked with marble. Nevertheless, company leadership was confident. In fact, at one point Channing Seabury complained to Gilbert that Walter Butler was "a pretty *smooth* individual." Seabury's misgivings dissipated as the capitol came together. Butler-Ryan employed the latest construction advancements, like a steam hoist on rails for maneuvering the heavy stones into place, as well as a turning lathe for carving fine details in stone.

Gilbert sought the expertise of Gunvald Aus, a pioneering Norwegian-born engineer. Aus immigrated to the United States in 1883, initially designing bridges for railroads. He was a consulting engineer on the Minnesota State Capitol, helping Gilbert decipher the means to overcome the stresses of the building's substantial dome. He returned to Norway in 1915, but not before assisting Gilbert with the engineering required for the Woolworth Building in New York.

The dome is three separate components. The inner dome, that part that visitors see when peering skyward inside the capitol rotunda, is a segmental sphere—that is, it is a segment of a sphere not quite equaling half a sphere. Surrounding and reaching above the segmental sphere is a cone, entirely beyond view. The cone is composed of steel and brick, and it rises to the capitol's top, supporting the lantern that punctuates the capitol's apex. Encompassing the cone is the exterior self-supporting dome. It is here where Aus's advice was most welcome, although disconcerting, as he explained that the outer dome as designed could not in fact function in a self-supporting manner. Gilbert was forced back to the drawing table to address Aus's worries. In time, the architect solved the structural riddle with strategically placed reinforcement, and the outer shell was completed. The extra effort proved worthwhile, for the elegant dome that Gilbert shaped, a marble cap superseded in size only by St. Peter's in Rome, was unlike most; frankly, its curvature was more aesthetically pleasing. If Gilbert had not labored so diligently to make it work, the Minnesota State Capitol may have resembled a glorified county courthouse.

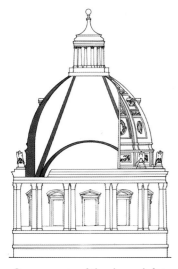

Components of the dome, left to right: outer dome, cone supporting the lantern, and inner dome.

Another firm that pondered the capitol dome was the R. Guastavino Company of Massachusetts and New York. Born in Valencia, Spain, Rafael Guastavino Moreno was educated at the Escola Especial de Mestres d'Obres in Barcelona. He arrived in the United States two years before Aus. An early innovator of fireproof construction, he introduced a method of building commonly known as Guastavino vaulting, which is a means of constructing thin, yet very strong vaults composed of hollow tiles. The Boston Public Library (1895) was the first significant American building to incorporate his method. This vaulting was used most notably in the capitol dome, ground floor and basement ceilings, and porte cocheres.

Gilbert also found employment at the jobsite for his longtime friend William Albert Truesdell, an engineer perhaps best recognized for the rare helicoidal stone arch bridge he designed on St. Paul's East Seventh Street in 1883. Unlike Truesdell, Guastavino Moreno, and Aus, however, most of the men laboring on the capitol were not engineers but tradesmen, including bricklayers, carpenters, iron workers, plumbers, and sheet-metal workers. Since construction of the building required vast quantities of stone, naturally the worksite hosted numerous stonecutters and stone carvers, most foreign-trained immigrants, but also many born in the United States.

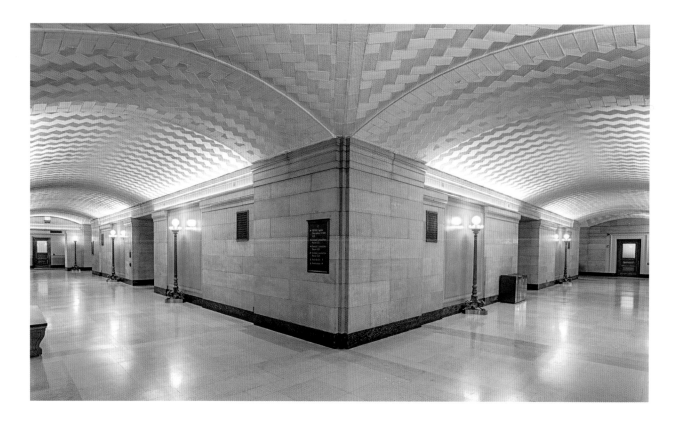

Guastavino vaulting in the ground floor.

Joseph Bourgeault was from Quebec, Canada, and served as a shop foreman. His eldest son, Joseph Jr., was a professional clarinetist who also worked at the capitol as a foreman. Albert, another son, was a stonecutter. Scotchman William J. Hutcheson was a partner in the Chicago firm of Purdy and Hutcheson, which was subcontracted by Butler-Ryan to carve many of the stone components of the capitol, including the twelve magnificent eagles encircling the dome, as well as the six figures on the façade's entablature signifying humanity's virtues. Like Albert Bourgeault, Everett Shahan cut stone. The twenty-one-year-old was thought brilliant. He constructed a model of the capitol on the floor of the gymnasium in the St. Paul YMCA. Using this model, he calculated the dimensions of the hundreds of pieces of marble composing the dome.

A number of stoneworkers at the capitol arrived from the South, especially Georgia, home to the marble that primarily sheathed the capitol's exterior. The Butler-Ryan Company needed to hire employees who were familiar with working marble. The company leased a quarry in Tate, Georgia, where stone was harvested and shipped to St. Paul, the largest blocks being six feet square, twelve feet long, and roughly thirty-six tons in weight. Wages for stoneworkers in Georgia were far below those of stoneworkers in Minnesota, so many tradesmen from Georgia relocated to St. Paul to work on the capitol. Not only were these workers familiar with the stone, but they understood how to work the machinery that cut and polished it. Initially, about one-third of the machine operators were from Georgia, but over time the number of local men

operating the machines increased as they learned from the experience of the others. Emmett Butler of Butler-Ryan recorded that about a dozen African American stoneworkers came to St. Paul from Tate, Georgia, to work on the capitol.

Not all of the black stoneworkers on the construction site were from Georgia, however. Casiville Bullard, a stonemason, bricklayer, and carpenter, arrived from Memphis, Tennessee. The son of formerly enslaved people, he had only a third-grade education. Young Bullard grew up in the cotton fields, given the responsibility of caring for his baby brother, whom he carried from row to row as he picked. He escaped the cotton fields when a relative taught him bricklaying and masonry. He became a talented tradesman, specializing in laying granite, marble, brick, and concrete, as well as flooring of pine and oak. He may have worked in St. Paul beginning in 1898, but he moved permanently to the community in 1902. He told his ten children that he came to Minnesota because he "was called" to work as a stonemason on the capitol. Bullard worked on other large buildings in St. Paul, including the federal courthouse (now Landmark Center), the public library, and the Highland Park Water Tower, and he built two homes for his family, one of which is now in the National Register of Historic Places.

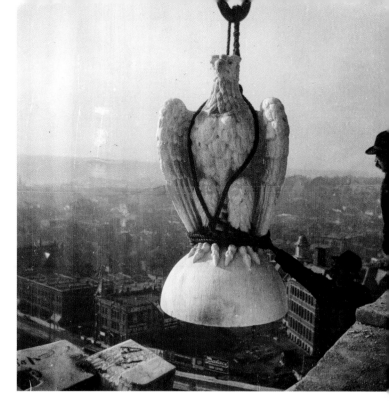

One of twelve eagles is installed on the dome, 1901.

Stoneworker Casiville Bullard with his wife, Addie, and the first four of their ten children. From left: Casiville Jr., Lilly, Janet, and Howard, about 1909.

It is not surprising that many African Americans in the South worked in the trades. Before the Civil War, in communities across the South, enslaved people did the bricklaying, stone masonry, carpentry, plastering, painting, cabinetmaking, gunsmithing, and blacksmithing as well as milling, shoemaking, spinning, and weaving. These skills continued to be passed to subsequent generations after the Civil War, and for some time blacks in the South dominated these occupations. The tradesmen who moved to Minnesota joined a small African American community—by 1910, it numbered just over seven thousand, less than a third of a percent of the overall population.

THE STONEWORKERS, both black and white, cut, shaped, and polished the stones that built the capitol. Butler-Ryan constructed a large shed at the northwestern corner of the worksite, within which were the machines that shaped the marble under guidance of experienced hands. The massive blocks of marble arriving in St. Paul from the Georgia quarry via railroad flat cars were stacked outside the shed. The cutting and planing machines hummed virtually all day. One specially designed apparatus created by Butler-Ryan cut the flutes within each column. These advancements of the industrial revolution were fully displayed at the capitol site, and newspapers did their best to explain to an enchanted public how the machines functioned:

> The saws are two long strong steel blades set in a movable rack and drawn to and fro across the blocks. A stream of sand and water is kept pouring over the blocks to feed the saws, so they will not become clogged, but will work through without friction . . . at the rate of four inches an hour. . . .

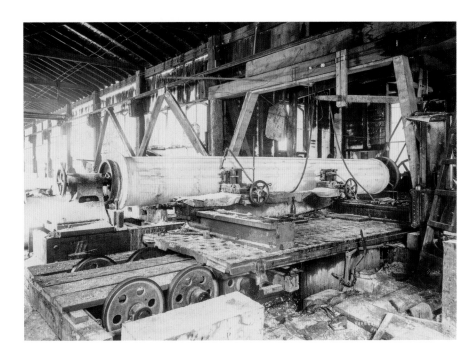

Stoneworkers, using William Butler's specially designed machine, carved flutes in columns used on the exterior. The apparatus is shown in the stone shed, probably before 1900.

From the saw gang the marble slabs are taken to the planers and polished. The planers look like guillotines [with] knives which are fixed rather than descending blades. Two hours are required for the polishing of a slab six feet long. When the slabs are removed from the planers they are smooth as glass.

While the machines worked well for cutting and polishing, much of the carving was completed employing hand and pneumatic tools in the stonecutters' shed. Other carving was done *in situ* atop scaffolding.

ZEBULON OLSON was a hoist operator, a Swedish immigrant who abandoned the poverty that the sociopolitical system of the homeland heaped upon its citizens for the economic and political opportunities of America. He helped set the tens of thousands of stones that composed the exterior of the handsome capitol. Elaine Olson Ekstedt explained that her grandfather took a small piece of the stone as a keepsake, carving it in the shape of an egg in memory of his labors. "Grandma Olson had this [egg] on the buffet," she said. "He took a chip from the construction process and put it in his pocket and made the egg later."

The Rachac family emigrated from Bohemia (now Czech Republic) in 1863. Their son, John, was fourteen at the time. He became a carpenter. After completing much of the fine carpentry at James J. Hill's mansion on St. Paul's Summit Avenue, he became one of the chief carpenters on the capitol project. When his family arrived in Philadelphia in the first week of July 1863, their train was halted for three to four days because of the battle taking place at Gettysburg, Pennsylvania. A century and a half later, after visiting the Minnesota State Capitol, Julie Kierstine, John Rachac's great-granddaughter, remarked: "There we are in the governor's suite, looking at these panels. We know he

The toolbox and carpenter's tools used by William Martin Knudsen during the construction of the capitol.

worked on some of the finishing work in the governor's suite, and there is this massive painting of the Battle of Gettysburg. . . . I wonder if he ever knew that there were going to be paintings up there of the Battle of Gettysburg."

Construction was dangerous work. Stonecutter Felix Arthur of Georgia died in May 1898 after he became entangled in a marble planer in the stonecutters' shed. In April 1900, Alfred Swanson was working on scaffolding that was undermined when a wagon ran over one of its ropes. The scaffolding collapsed, and he was killed. Four other men also lost their lives in falls during the project. Newspapers in both St. Paul and Minneapolis railed against the unsafe work conditions, and perhaps it had an effect, as no workers died over the last couple years of construction.

Oddly, but not surprisingly, a bronze plate placed inside the copper box in the cornerstone of the capitol building did not include the name of a single worker or contractor that labored on the building. Certainly it held the names of the Board of State Capitol Commissioners and legislators, dignitaries, and associates. Cass Gilbert's name was there, of course. But there is no John Rachac or Casiville Bullard, no Joseph Bourgeault or Everett Shahan. When the capitol reopened in 2017, however, this neglect was rectified, at least in a small way. The Capitol Area Architectural and Planning Board (CAAPB) held a design competition for Minnesota sixth graders, all of whom were invited to submit to the CAAPB a design for a commemorative plaque in memory of those who died and those who labored on the capitol.

CAPITOL MALL

From the beginning, Gilbert had grand plans for a capitol mall. In fact, he amended his capitol contract to note that he had control over "embellishments of the grounds." In 1900, with much left to do on the building, he had one of his draftsmen complete a watercolor of the capitol and site featuring impressive terraces and approaches. In late 1901, Gilbert presented the watercolor to Seabury, who presented it to the entire board in February 1902.

It is unsurprising that Gilbert sought a capitol mall of grand approaches, ornate buildings, and statuary, all of which reflected the Beaux-Arts school of thought and its tangible American representation in the Chicago Exposition. The watercolor led to Gilbert's earliest detailed plan for the mall in 1902, which was refined further by 1903. The St. Paul City Council formed a commission to investigate its feasibility, and in 1906 the commission issued "The Report of the Capitol Approaches Commission to the Common Council of St. Paul."

The mall as proposed in 1906. The current placement of Interstates 94 and 35E, St. Paul College (A), Minnesota History Center (B), and Xcel Energy Center (C) overlay the drawing.

The first leaf of the oversized report depicts a 1906 plan of the capitol area and much of the surrounding neighborhoods and roadways. Grossly, Wabasha Street cuts diagonally in front of the capitol. The plan also showed those sections of the city many people had expected to be acquired and made a part of a capitol mall, including the awkwardly positioned portion of Wabasha Street. In essence, the commission envisioned three attractive approaches to the capitol. The central approach was to reach directly south from the capitol to the Seven Corners area of West Seventh Street, a substantial distance that would link a busy part of the city to the statehouse. A second approach reached southeasterly to St. Paul's heart and was composed of a broad, rectangular mall framed by Cedar and Wabasha Streets. The third approach spanned southwesterly to Masqueray's cathedral, a boulevard bookended by Beaux-Arts glories. Webster Wheelock, editor of the *St. Paul Pioneer Press*, remarked: "This approach will afford a vista between the two most imposing and beautiful buildings in the city."

The commission's view relied on several suppositions, including knowledge that other communities had successfully completed such works and Minnesota could as well. The commission additionally supposed that costs of property acquisition would be higher in the future. Ultimately, the commission believed, the state and the city of St. Paul welcomed a capitol mall as a finishing accent to the fabulous building and perhaps both were ready to appropriate the necessary funding. Neither was. The following year, however, the state demonstrated it still was interested in a mall when it began making modest purchases of private property in the capitol vicinity.

It is odd to imagine, but for many years after the capitol was constructed, Wabasha Street coursing across the building's toes was not the most unfortunate aspect of the building's setting. The capitol was surrounded by a collection of residences and commercial buildings, many ramshackle. In part, the Capitol Approaches Commission believed that public officials would warm to its recommendations because the statehouse's "beauties [were] hidden amid squalid surroundings." Instead, the building's uninviting environs persisted for decades, finally arriving at national embarrassment in 1936 when *Fortune* magazine contrasted Minneapolis and St. Paul. The brutal dissection of the capitol city was augmented by a watercolor of the State Capitol blemished by dilapidated surroundings. The caption read: "Cass Gilbert Designed the Capitol; the Slums Got There Unaided."

Aerial view, 1930. Wabasha Street cuts diagonally across the grounds; the Judicial Center, which was built in 1918 for the Minnesota Historical Society and the Department of Education, is at lower right.

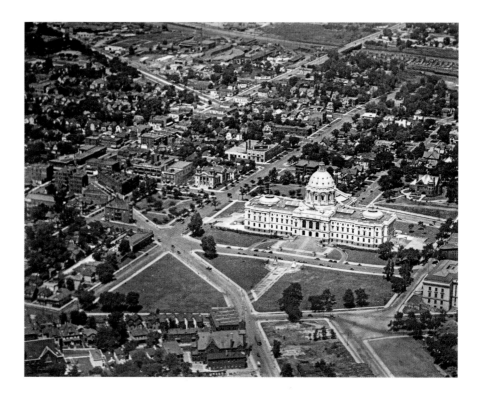

Gilbert moved on to many other spectacular commissions, and he died two years before the *Fortune* piece was published. But as late as 1931, he was still attempting to get Minnesota and the city of St. Paul to complete a capitol mall. He had been invited to the state by a coalition of businesses, the city of St. Paul, the St. Paul Planning Board, and the Ramsey County Board of Commissioners, all seeking his perspective on Governor Theodore Christianson's proposal to erect an office building immediately north of the capitol. Gilbert released his report in early 1931, and again stressed the desire for long, axial approaches. The approach plan was not acted upon, although in 1932 the handsome Minnesota State Office Building was erected just to the southwest, rather than to the north, of the capitol, directly opposite the attractive structure built to

the southeast in 1918 for the Department of Education and the Minnesota Historical Society. Taken together, the three buildings helped balance the setting, yet Wabasha Street continued to disturb uniformity.

World War II forestalled comprehensive work on a capitol mall, but by the mid-1940s, Clarence H. Johnston Architectural Associates, founded by one of Minnesota's foremost architects, and Morell and Nichols, a prominent landscape architectural firm, had developed the Minnesota State Center and War Memorial Plan. It followed much of Gilbert's mall concept but was scaled back. It was subsequently refined by Morell and Nichols into the "Over-All Plan of Proposed Development." A Veterans Service Building Commission was established in 1945, with the state legislature appropriating funds for both the building and improvement of the capitol grounds. The city of St. Paul sold bonds to raise funds for property acquisition. Much of the memorial building to veterans was finished by the mid-1950s, but it would not be final until 1973, its modern aesthetic authored by a young architect from Washington, DC, W. Brooks Cavin Jr. Believed the

Demolition along Wabasha Street, 1951. Trinity Lutheran Church was one of two churches destroyed as the capitol mall was cleared.

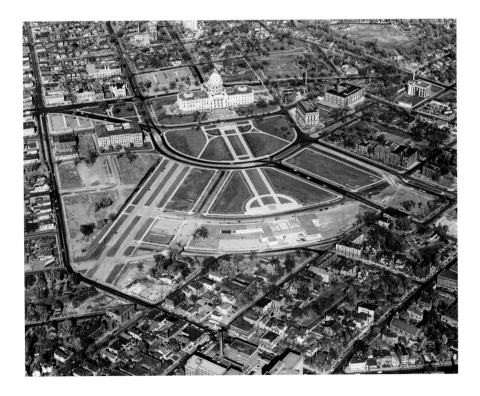

An aerial view shows the new capitol mall, 1954.

"first important example of modern architecture in St. Paul," it punctuated the south end of a pedestrian approach that was completed as part of the mall improvement project. It undermined Gilbert's vision of a long, unobstructed south approach to the capitol, but the clever Cavin raised the main office block atop a colonnade, creating at least an allusion to Gilbert's notion. The concept was quashed altogether in 1967 when a completed Interstate Highway 94 entirely severed the capitol grounds from St. Paul's core.

Roughly seventy-five buildings and structures were demolished to make way for the capitol mall, including residences, apartments, and a couple of churches. Roadways were rearranged, and the diagonal cut of Wabasha Street was eliminated. By 1955, the footprint of the mall we have today was largely in place, with buildings added periodically, largely following the plan of Morell and Nichols. The Transportation Building was finished in 1956, and two years later, on the one hundredth anniversary of statehood, the Centennial Building was dedicated. The Administration Building was constructed in 1968.

A year earlier, the mission, role, and authority of the Capitol Area Architectural and Planning Board (CAAPB) was established. The CAAPB is an important body, having planning and architectural oversight of the capitol and grounds. The CAAPB has modified the Morell and Nichols plan to accommodate the state's continuing needs. These include the Judicial Center, a postmodernist edifice with an arched footprint springing from the rear of the old Minnesota Historical Society building; in the early 1990s, the society moved to a new building across the freeway.

Numerous memorials are located on the capitol grounds, including those honoring Minnesota veterans of the country's wars. There are other commemorative works, such as those to governors Knute Nelson, John A. Johnson, and Floyd B. Olson. A memorial exists for civil rights leader Roy Wilkins, and another for Hubert H. Humphrey, perhaps Minnesota's most prominent politician. The grounds host commemorations to Charles Lindbergh, Christopher Columbus, and Leif Erikson as well.

THE CAPITOL AT WORK

Over the decades, the capitol building has served many needs for the citizens of Minnesota. It is the seat of government, although it has not always been a comfortable one; the spaces chiefly beyond public view have been altered and realtered to accommodate the needs of legislators and their staffs. In fact, almost from the time of construction, some have criticized the interior layout, claiming that Gilbert was more interested in the aesthetic harmony of the components than in the practical functioning of the building. The assessment is probably correct. Nevertheless, the "beauty pile," as some called it early on, largely has retained its original interior, perhaps because the people of Minnesota and their representatives realize that democratic federalism is more competently expressed in beauty than inelegance.

Changing societal needs brought changes in space use. By 1918, the Department of Education and the Minnesota Historical Society had moved from the capitol to a new building, freeing space for other offices on the ground floor. From 1930 to the 1960s, the Department of Motor Vehicles was sited on the ground floor of the capitol. The governor's portraits were displayed in the first-floor corridors beginning in 1944. A decade later, the portraits, as well as all else in the capitol, were lighted via alternating current power, which replaced the original direct current. In the early 1980s, the capitol was connected to District Energy St. Paul, the largest hot-water district heating system in North America.

On February 11, 1936, purchasers rushed to the Department of Motor Vehicles office in the capitol to pay for new 1936 license plates before a late penalty went into effect. About 765,000 registrations were expected that year.

The Minnesota Legislature operates on a two-year cycle. Legislators may meet between January and May of each year of a biennium for a total of 120 legislative days. The representatives cluster in their respective chambers to debate, write, and pass the legislation that governs the North Star State. The building hums with activity as legislators move between meetings, citizens attend hearings and lobby their representatives, school groups and visitors take tours, and journalists interview newsmakers. All can absorb the architectural and artistic cogitations of Gilbert's mind as they work through the challenges of the legislative process. The spectators' galleries in each chamber allow firsthand perspective on the oratory and occasional impoliteness that make the state run.

In the capitol, the legislature does the people's business. All manner of legislation is addressed, from funding for education and highways to health care, prisons, disaster relief, state parks, taxes, environmental concerns, and much more. The legislature recognized women's right to vote in presidential elections in 1919, after considerable effort by the state's suffrage movement. The following year, Minnesota's lawmakers ratified the Nineteenth Amendment to the US Constitution, making the voting privilege official. One of the legislature's low points arrived with a 1925 law validating censorship of publications deemed scandalous or obscene. The law subsequently was used to sue the *Saturday Press*, an overtly anti-Semitic newspaper known for its attacks on public officials. The law was challenged and yet upheld by another principal occupant of the capitol, the Minnesota Supreme Court. Ultimately, the case, known as *Near v. Minnesota*, was carried to the US Supreme Court, which overturned the law in 1931.

Beyond its roles as governing and judicial hub, as well as tourist attraction, the capitol rightly is a magnet for all manner of sociopolitical actions. It is the focal point for those convinced that government needs awakening. For instance, the Farmers' Holiday Association (FHA) marched on the capitol in March 1933, roughly twenty thousand strong. The FHA served as a voice for farmers fighting depressed agricultural prices and the resulting foreclosures during the Great Depression. Several months before the march on the capitol, the FHA essentially shut down much of Minneapolis and St. Paul by blockading ten major thoroughfares. In 1985, farmers again protested at the capitol, this time filling the roadways around the building with tractors and demanding a moratorium on farm foreclosures.

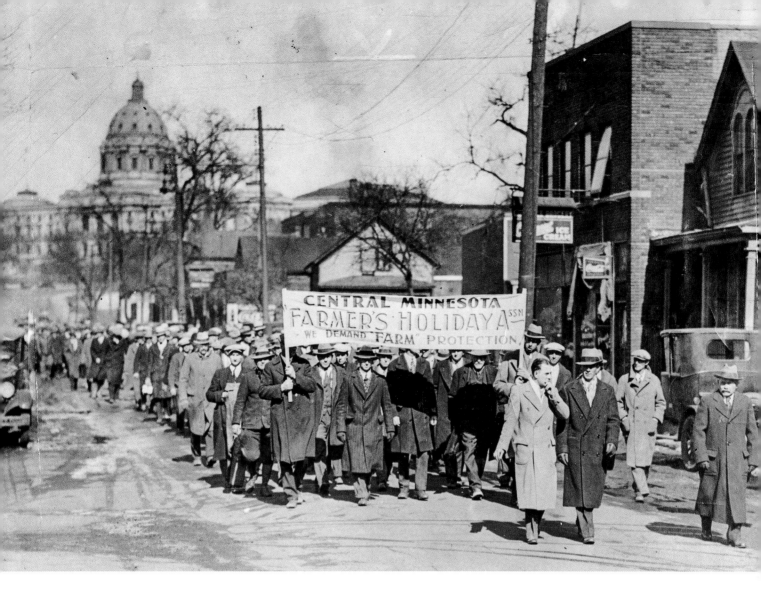

In 1937, the People's Lobby, a group seeking educational and social reform, rallied at the capitol, taking over the Senate chamber. Two years later, workers protested budget cuts to the arts program of the Works Progress Administration, which was created to salve the economic pain of the Great Depression by putting the unemployed to work on government-funded programs.

In early 1963, Pine Bend resident George Serbesku provided an early Minnesota example of environmental protest when he carried oil-covered birds to the capitol, where he sought the assistance of state government. The birds, mostly ducks, had suffered from millions of gallons of petroleum and soybean oil spilling into the Mississippi River in late 1962 and early 1963. This environmental calamity was the seed for the creation of the Minnesota Pollution Control Agency. In the late 1960s and early 1970s, Minnesota's capitol was the site of protests against the war in Vietnam. A huge rally took place in May 1970 after the invasion of Cambodia and the subsequent killing of four unarmed college students at a protest at Kent State University. Every January since 1973, opponents of legalized abortion gather at the capitol to mark the anniversary of the *Roe v. Wade* decision; they are joined by counter-protesters.

A delegation of farmers from central Minnesota leaves the capitol after the Farmers' Holiday protest, 1933.

FACING PAGE, CLOCKWISE FROM TOP LEFT: Vikings supporters celebrate the passage of the Viking stadium bill, May 2012. The first Martin Luther King, Jr. Day, January 16, 1978. Supporters of marriage equality, May 2011. Minnesota Remembers 9/11 Rally, September 16, 2001.

THIS PAGE, CLOCKWISE FROM TOP LEFT: Tom Stillday, spiritual leader of the Red Lake Nation, at the signing of an agreement implementing the Indian Child Welfare Act, February 22, 2007. Annual March for Life, organized by Minnesota Citizens Concerned for Life, January 22, 1986. Rally to support funding for Local Government Aid, 2009. Term limits rally, 1994.

Besides protests and demonstrations, the capitol historically has served as host to many celebrations, including the gathering of thousands on the capitol mall after the American hostages in Iran were released. A three-hundred-foot-long yellow ribbon stretched across the capitol's façade. Each year in October, the Twin Cities Marathon concludes at the capitol. In 1987, the Minnesota Twins World Series Championship team paraded through Minneapolis and St. Paul, destined for the mammoth gathering at the capitol. (Who can forget Kirby Puckett in a fur coat, sporting an aviator's cap?) The motorcade for the Twins World Series Championship team from 1991 merely drove by the capitol, and in the view of some, so did the hopeful wishes of future World Series championships. For many years, the capitol grounds hosted the Taste of Minnesota, a celebration of the state's diverse palate. Fireworks, live music, and

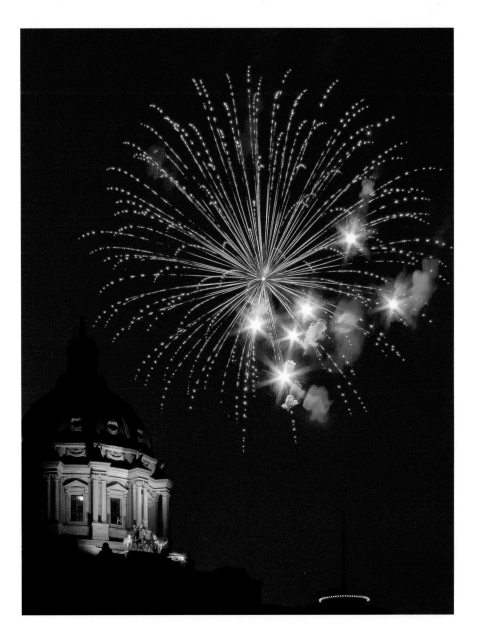

Fireworks explode over the capitol in 2008 as Minnesotans celebrated the 150th anniversary of statehood.

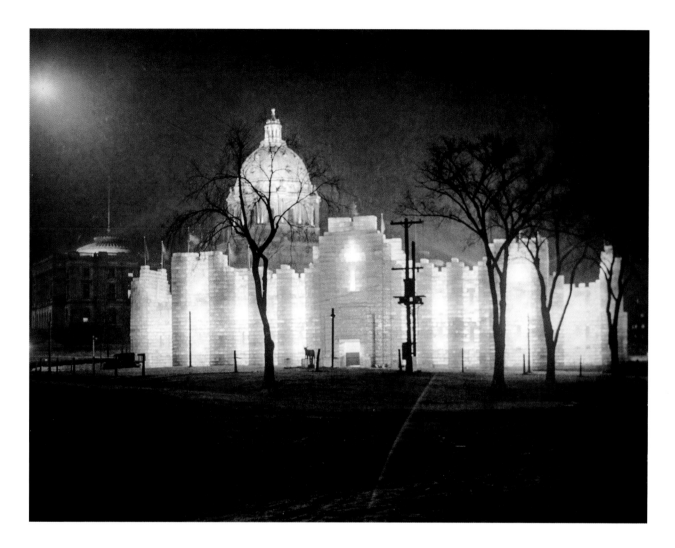

kids' rides were part of the festivities. At times the capitol has been the backdrop for activities during the St. Paul Winter Carnival. In 2004, the grounds hosted the carnival's ice castle. Not all events have been festive, however. The ceremonies on the mall on Memorial Day and Veterans Day are respectfully solemn.

The capitol as a place of reverence began in 1905, when William Colvill lay in state as the regimental battle flags were transferred from the old statehouse to the new. However, these events are most uncommon in Minnesota's capitol. More than seventy years later, Hubert H. Humphrey was so honored. His flag-draped casket with honor guard was viewed by thousands of Minnesotans, acknowledgment of his profound impact on the state's politics. Perhaps the state's most influential political leader, he served as vice president of the United States during the Lyndon B. Johnson administration. He later ran for president but lost a close election to Richard M. Nixon. Humphrey actively supported the merger of the Democratic Party and the Farmer-Labor Party, which brought about the Democratic-Farmer-Labor (DFL) Party that we know today.

The St. Paul Winter Carnival's ice palace, built on the capitol grounds in 1937.

CAPITOL RESTORATION

More than a century after it was constructed, Gilbert's Renaissance masterwork continued in its historical function, but it had suffered from numerous harsh winters and deferred maintenance. The capitol may have appeared fine from a distance, but leaks and cracks were multiplying, and at close inspection, problems were grossly evident. The capitol's perpetual problem of water leakage, especially around the dome, became clear as early as 1912. When debris clogged or broke downspouts, the system for preventing leakage in the dome failed, and inadequate repairs compounded the problem. In addition, condensation of warm air that rises into the space between the inner and outer dome can cool, and condense, and leak around the edges of the dome. Whatever the source, the infiltration damaged some of the art in the rotunda. This was not news to those intimately familiar with the building, but it likely was news to much of the public; it is not as though the capitol had undergone no work. Indeed, it had seen much.

The capitol's first major renovation spanned a quarter century, from 1930 to 1954. The second renovation was much briefer, 1968 to 1972, but nevertheless brought such memorable alterations as carpeting placed over original tile flooring and original vaulted ceilings masked by acoustical tiles. A third major effort—the first-ever restoration of capitol spaces—took place from about 1985 to 1990, when the governor's reception room and private offices and the House and Senate chambers were brought back to their original appearance. Additional work has taken place since, including on the quadriga in the mid-1990s, when the golden statuary was removed from over the main entrance and shipped to a restoration studio in Connecticut. Almost all of this work has been an effort to make the capitol fit changing needs; only occasionally has it been restoration or rehabilitation.

Historic preservation as policy when contemplating care of the capitol received a substantial boost with Governor Rudy Perpich. In the early 1980s, the governor wished to restore his offices and the reception room to their former glory. Drapes similar to the 1905 originals were reproduced, covered in fine gold appliqué stitched by first-generation Hmong women, known for their needlecraft expertise. A major part of the project involved locating displaced historic furniture and returning it to historic spaces. This was a significant undertaking of the Minnesota Historical Society (MNHS), an institution uniquely positioned for the task as the state's principal repository of historical information. Moreover, it managed the capitol as a historic site. The historical society reviewed its collections and discovered where pieces had originally been located in the capitol. Since that time, the MNHS has continued to seek

Workers removed the copper sheeting from the dome over the Senate chamber to repair the water damage under it, November 4, 2016.

historic pieces of furniture which were removed as various state agencies relocated from the building. The goal is to bring back as many of these furnishings as possible. More importantly, however, since that early preservation effort, the MNHS has been intimately involved with any discussion of alterations, restorations, and rehabilitations at the capitol.

Much of the maintenance and restoration over the years has been piecemeal and inefficient, reminiscent of that done on the fantastic cathedrals of Europe, perpetually obscured by metal scaffolding that moved from one location to another in an attempt to keep up with faltering buildings. By the 2010s, however, state leaders began to coalesce around a plan for a comprehensive restoration on the capitol. This was spurred in part by a few events, one being a planned $4 million makeover of the capitol dome in 2009. Initial work on that project revealed that the capitol was suffering in many areas, as the CAAPB had been claiming for years. Unsettling events helped illustrate the point. In 2010, a section of the Gemini zodiac inside the upper reaches of the capitol dome—a work of fine art composed by prominent artist Elmer Garnsey—broke free and wafted downward. Fortunately, because of work taking place in the dome, its fall was arrested by a construction tarp, limiting further damage to the valuable mural. This event was followed in 2012 by the iconic image of Representative Dean Urdahl hefting a stone scroll while speaking in the House

chamber. His prop had been removed with a few taps of a hammer, proving that the capitol exterior was shedding stone.

Further investigation convinced the reluctant it was time to pony up for the state's principal monument. A comprehensive master plan was completed in early 2012. The authors explained its purpose: "The Minnesota State Capitol Master Plan document is a living document that provides a 20 year view of the restoration, preservation and maintenance of the Capitol." Although the state legislature wrangled somewhat over timing, funding, and overall scope, the state's leaders understood that comprehensive restoration could no longer wait and that the aesthetic delight that is the State Capitol need not forever be blemished by piecemeal repairs.

A Historic Structures Report (HSR) was completed by early 2014. A multi-volume cure for insomnia, the necessarily ungracious compilation was nonetheless very useful, its purpose to "create a usable description of the Capitol, what it is and how it came to be," as well as to guide the renovation work and to provide a "framework that can be used by future designers and decision makers." In essence, the HSR is the medical record of the capitol, offering details about the treatments it has undergone over the years while at the same moment detailing its current condition.

The governor's reception room, filled with the scaffolding needed for the restoration of the ceiling plaster, became another part of the jobsite by July 15, 2016.

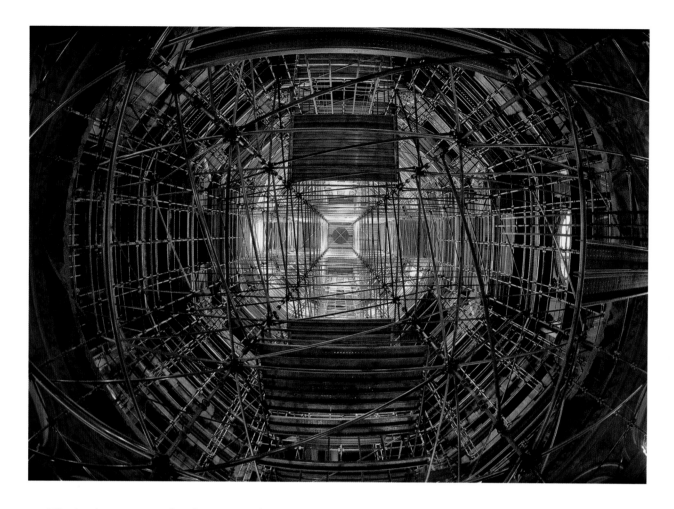

The lead contractor for the restoration was Hammel, Green and Abrahamson, Inc. (HGA), a prominent engineering, architectural, and planning firm established in Minneapolis in 1953. HGA has completed many projects, including efforts on General Mills World Headquarters, a major international commercial enterprise based in Golden Valley, Minnesota. HGA was assisted in part by the architectural firm Schooley Caldwell Associates, Inc., which designed the handsome Griggs Reservoir Boathouse in Columbus, Ohio. Construction management was the responsibility of JE Dunn Construction Group, one of the largest general building contractors in the country. Founded nearly a century ago in Kansas City, Missouri, JE Dunn restored the Kansas State Capitol in Topeka and the Wyoming State Capitol in Cheyenne. Their experience shows in the care and craftsmanship of the renovation.

The capitol demanded extensive attention, and the preservation effort became the largest in the building's history, with roughly four hundred laboring to repolish our capitol jewel from 2014 to 2017. Most of the structural and mechanical improvements were hidden from sight, such as installation of electrical and plumbing components, positioning of new ductwork, and installation of data and fiber-optic cable. Betterment was more obvious in the exterior sheathing, where the marble was cleaned, repaired, restored, or replaced

Restoring the decorative and fine art on the ceiling of the rotunda required the installation of scaffolding that reached the top of the interior dome, approximately 140 feet above the floor, July 15, 2016.

using marble from the same Georgia quarry that was the stone's source. The lightly earthy dappling of the capitol's cleansed face once again commands the attention of the passerby. Exterior steps have been reconstructed with colossal slabs of granite, basement sections opened to reveal original limestone foundation walls and original arched tile ceilings, skylights uncovered and restored, moldings cleaned and painted, and stenciling restored to its original 1905 appearance.

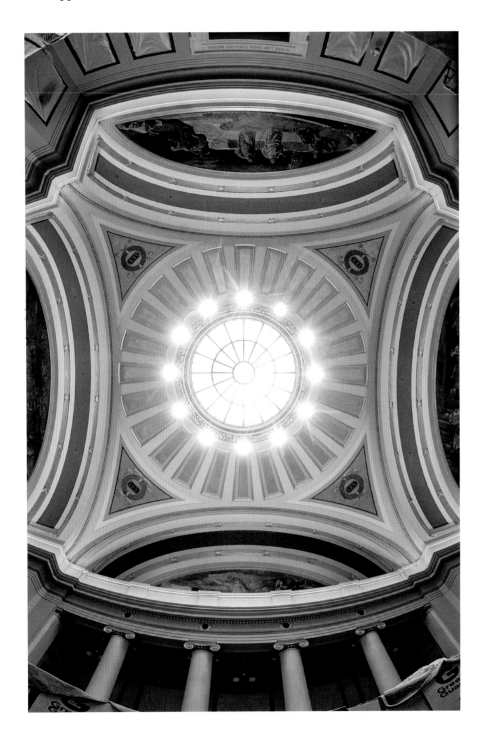

The skylight above the Supreme Court, reopened and restored.

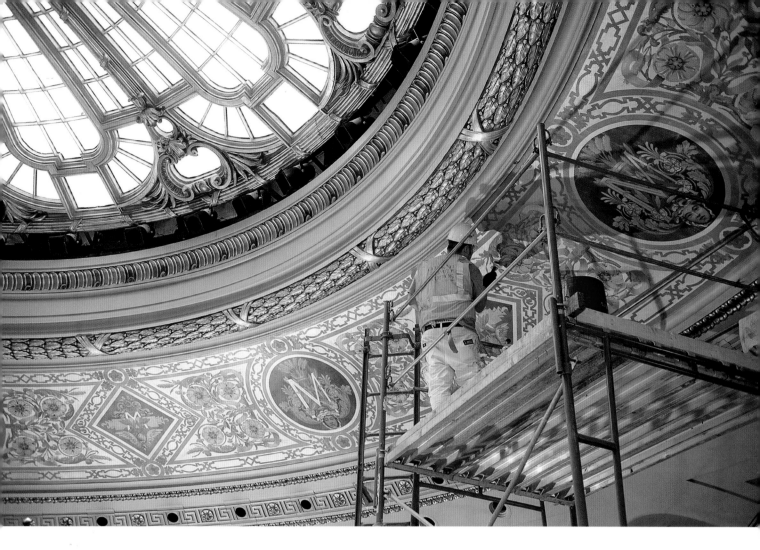

Restoring the decorative art above the House chamber, July 21, 2015.

Restoring the murals proved challenging because of their fixed locations, delicate nature, and high value. The value of the murals is intertwined with their location in the capitol building. Because they are fixed art, intentionally designed and created as a part of the building itself, it would be difficult or impossible to remove them from the capitol, and such a move would likely diminish their value. In contrast, easel art, which is usually framed and can be moved from one location to another, can have a market value. All agree, though, that art in the capitol is extremely valuable—perhaps literally priceless.

In the capitol's long history, never had there been a comprehensive restoration plan for the murals. Any significant mural work resulted from an emergency situation, such as a piece requiring repair. Until recently, mural maintenance or conservation generally had been undertaken by well-meaning nonprofessionals who to some extent harmed the paintings. For instance, about every two decades, smoke, coal dust, and other impurities were cleaned from the murals, usually by workers using a pail of water and a brush. Perhaps more alarming, occasionally image details were lost because the overall composition was altered in a "restoration" effort; in some instances, elements were removed, and in other cases, details that did not exist originally were added. Using Henry Oliver Walker's *Sacred Flame (Yesterday, Today and Tomorrow)* as an example, capitol site manager Brian Pease explained: "There were so

many different additions to that painting. There's a center figure in red. And if you look at the historic, the original, photo, she had a bare arm. But for whatever reason, in the thirties they put more drapery over her shoulder, and they added folds." The conservators who labored over the murals for the recent restoration studied the original photograph and realized that the folds actually flowed differently, so they improved the painted image. All fine art restoration at the capitol was undertaken by Page Conservation of Washington, DC, a three-decade-old firm well known for its expert craftsmanship with painted works of art. Page was assisted in the endeavor by Parma Conservation of Chicago and Hartmann Fine Art Conservation Services of Carlisle, Pennsylvania. Conrad Schmitt Studios, an art enterprise established in Milwaukee, Wisconsin, in 1889 by Conrad Schmitt, the son of Bavarian immigrants, restored the decorative art.

Ensuring murals reflect original composition has been only one issue. Much of the conservation has included removing grime, yellowed varnish, and overpainting. Sometimes this was accomplished with solvents, but if a solvent's chemical composition is similar to that of the original artwork, it is possible that original material beneath the nonoriginal material may be removed as well. Thus conservators also employed dental picks, knitting needles, bamboo skewers, bone folders, or even scalpels to gently chip away the varnish.

Restoration work, before and after, shows the degree of discoloration from grime and aged varnish on a lunette above the east grand staircase.

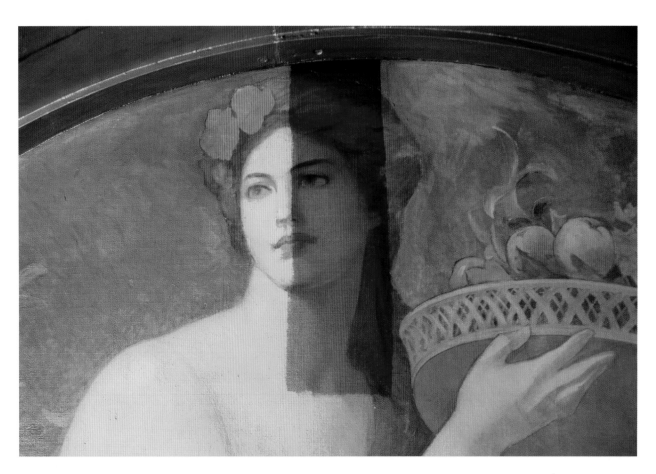

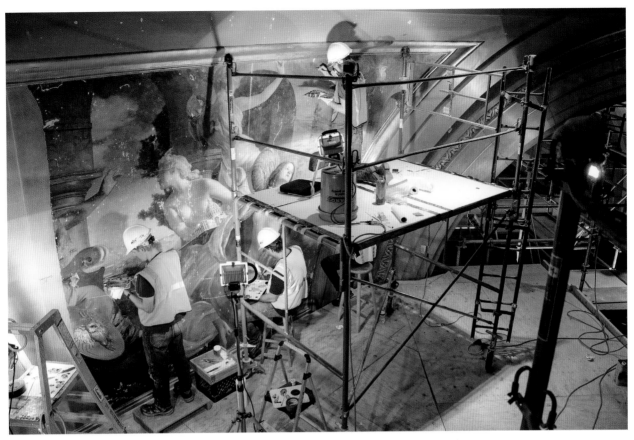

Art conservators at work on the fourth (northeast) panel of *Civilization of the Northwest.*

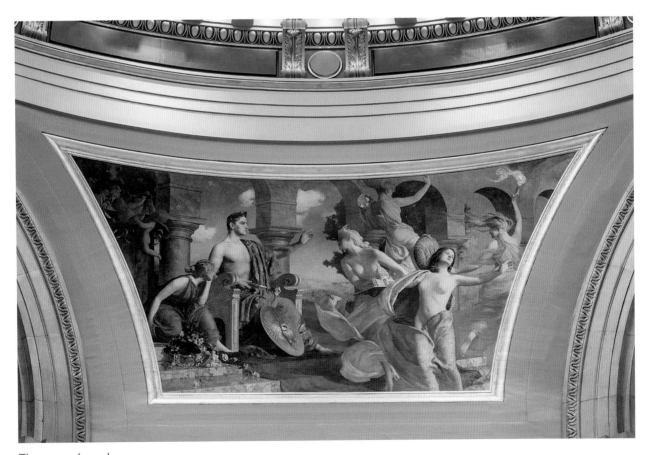

The restored panel.

Duane Olson, Heidi Xu, and Stoyko Stoykov prepare the dome's finial for the application of gold leaf, June 20, 2012.

Harvey Jaeger, project manager for 2010–12 dome restoration project, January 21, 2011.

Left to right: Randy Long, Robert Reiter, and Bart Chenuy, July 9, 2014.

Sysomphone Khotsyphon and Gary Behm inside the rotunda's chandelier, February 17, 2011.

ABOVE: Zodiac lunettes before restoration. BELOW: Removing a lunette for conservation work.

Some of the most challenging conservation work required removing murals from walls, never a task undertaken lightly. Specifically, five of Garnsey's zodiacs within the dome and one of Simmons's murals in the rotunda required removal from walls. This need largely resulted from damage to the plaster walls themselves. In the dome, the zodiacs are painted on canvas that adheres to a white coat of plaster, which is supported beneath by a brown coat. Behind this is brick forming part of the dome. In some instances, the white and brown coats had severely cracked and crumbled, undermining the murals' adhesion to the wall. In the worst cases, not only had the white and brown coats crumbled, but so had the brick, resulting in tearing of murals. All of this damage stemmed from water leakage in and around the dome. The murals were carefully removed from the wall, rolled, and lowered to the ground, and then shipped to a conservation lab for

treatment. The plaster and brick walls were repaired and the restored murals painstakingly reinstalled.

The completed restoration.

Additional work at the capitol included reconfiguring spaces, making them more usable for legislators and the public. In fact, public space has roughly doubled to nearly forty thousand square feet, a benefit derived in part from construction of a new building for Senate offices immediately north of the capitol. Policymakers like Governor Mark Dayton insisted that the capitol belonged to the people rather than elected officials, and the building's interior plan must make this plain. "My view is the public space is what's most important, and the rest of us should fit in accordingly," Dayton remarked. House and Senate leadership and members agreed with the governor. The expanded public space includes an enlarged information and tour center, and new meeting rooms, event spaces, and classrooms. Accessibility features throughout the capitol make the building available to all. While the new floor plan is not precisely the same as Gilbert's original, the principal spaces—the House, Senate, and Supreme Court chambers, the governor's reception room, and the public areas—largely have remained the same.

The building reopened to government business in time for the 2017 legislative session in January and celebrated in grand reopening festivities that summer. This restoration was a pricey endeavor; the $310 million price tag

includes $4 million appropriated to restore the decorative and fine art and to regild the beloved quadriga. But this is a once-in-a-century endeavor, ensuring another hundred years for Minnesota's testament to the democratic process, and the results are spectacular.

ANGST OVER ART

Cass Gilbert intended to blend architecture and art into a complementary assembly that spoke to Minnesotans at the turn of the twentieth century. But in the twenty-first century, many Minnesotans had been asking why the state's capitol hosted art that was offensive to them. By February 2015, a subcommittee of the Capitol Preservation Commission (CPC) was formed to research and make recommendations on both existing art (including military art, the governor's portraits, and some of the allegorical artworks) and potential new artworks that would reflect the changing face of Minnesota.

As the subcommittee met with Minnesotans from different parts of the state, former Minnesota Supreme Court justice and subcommittee co-chair Paul Anderson often opened with a simple but telling joke: "The past, the present, and the future went into a bar. It was tense." Earlier generations of Minnesotans had a powerful conception of what was significant to them, and in this instance, the notions were so important that they were woven into the fabric of the state's seminal expression of architectural identity. More than a century

later, Minnesotans are altering the expression, and our identity today no longer precisely matches that of 1905. In the future, it may be even more different.

Because of its design, the building is something of a museum of all that Minnesota had experienced through the beginning of the twentieth century. In fact, for many years, it had a dual role as statehouse and de facto museum. Public displays of high art were few, and the people could visit the capitol and see impressive architecture, statuary, murals, and easel paintings. Indeed, Howard Pyle's *The Battle of Nashville*, installed in the governor's reception room in 1906, is widely considered a masterwork. Copies of the painting have been included in hundreds of publications. With the maturation of Minnesota, more cultural centers developed, and the capitol's role as a museum diminished.

But the capitol is also the seat of government in Minnesota. It is the statehouse, or "people's house." Because it is not primarily a museum but a working public monument meant to represent all, it is unsurprising that many people of all backgrounds are disturbed by negative and inaccurate depictions of racial and ethnic heritage in pieces of art in the people's house.

The Battle of Nashville by Howard Pyle.

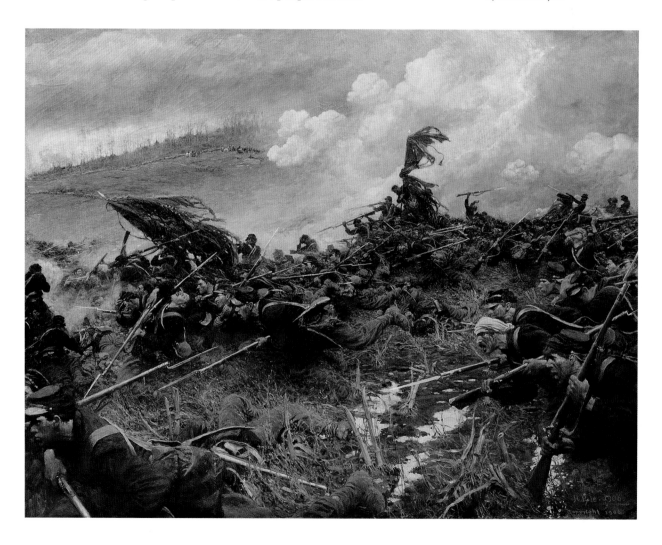

For instance, in the second panel of Simmons's *Civilization of the Northwest*, a youthful male drives from the land a cougar and a bear, the former representing cowardice and the latter savagery. Also driven away are a woman with the head of a fox, who carries nightshade, and a baboonish man carrying stramonium; the woman signifies sin, while the man depicts stupidity. The figures in all four panels are fantastical metaphors, in keeping with Beaux-Arts tradition and Simmons's commission to paint a classically inspired allegory. Because art is open to interpretation and reinterpretation, some who are not familiar with allegorical language speculate that the male figure represents an American Indian.

Civilization of the Northwest, though, proved less controversial than other works of fine art at the capitol. Two paintings in the governor's reception room and two in another location in the capitol generated the most vociferous opinions. From the time of the capitol's completion, Douglas Volk's *Father Hennepin at the Falls of St. Anthony* and Francis D. Millet's *The Treaty of Traverse des Sioux* hung in the governor's reception room. *Attack on New Ulm* by Anton Gag and *Eighth Minnesota at the Battle of Ta-Ha-Kouty (Killdeer Mountain)* by Carl L. Boeckmann were acquired at different times after the capitol was constructed and hung in various locations. Many Minnesotans find these works offensive. Minnesota's eleven Indian tribes and their representatives in the art discussions decried the depictions of American Indians in the paintings, insisting that the images are inaccurate caricatures of their heritage. They object to the patriarchal and condescending message delivered in *Father Hennepin*, as the friar blesses and names the Falls of St. Anthony while Indians rest subserviently. The Indian female in the image is topless; Dakota women would never have dressed that way. *Traverse des Sioux* represents the subjugation of the Dakota that resulted in a treaty that was intentionally deceptive and subsequently broken. The painting frequently served as a backdrop when the governor held a press conference. *Attack on New Ulm* emphasizes the violence of the Dakota attack but does not suggest its causes; *Ta-Ha-Kouty* depicts an attack on a gathering of Lakota, Yanktonai, and Dakota families, most of whom had not been hostile to the United States. Tribes asked that the paintings be removed from the capitol altogether.

The subcommittee conducted hearings across the state and an online poll to determine the feelings of Minnesotans. Although a clear consensus on the future locations proved wanting, the efforts of the subcommittee nevertheless revealed that Minnesotans largely understood the troubling aspects of these works, and overwhelmingly they stressed the opportunity to educate the public through the art.

Believing that art in the capitol should engage visitors and inspire return trips, the subcommittee recommended that the *Father Hennepin* and *Traverse des Sioux* paintings be removed from the governor's reception room and placed elsewhere in the capitol, still available to the public and with robust interpretation. No recommendation was made for either *Attack on New Ulm*

or *Ta-Ha-Kouty*. The group also recommended that the governor's portraits continue to be displayed, but in new ways that allow more context. Lastly, the subcommittee suggested that all six Civil War paintings in the governor's reception room and anteroom should remain in their historic locations.

The Minnesota Historical Society, which had final word on what would become of the paintings, next took up the art discussion in consultation with the CAAPB. After much thoughtful deliberation, the MNHS agreed with the conclusions of the Subcommittee on Capitol Art, that the Civil War paintings be returned to their historic locations in the governor's reception room and anteroom; the *Father Hennepin* and *Traverse des Sioux* paintings should be removed to a less prominent location of the capitol and robustly interpreted; and new venues should be found for *Attack on New Ulm* and, perhaps, *Ta-Ha-Kouty*. Moving these last four paintings did not sit well with some historic preservationists, who viewed their relocation as undermining the historical integrity of their original spaces, and some members of the public perceived a form of censorship. The MNHS initially agreed that only a selection of the governors' portraits should be rotated and displayed but, after strong reaction from legislators and others, decided to return them all to the capitol. Governor Dayton, who had wanted to see fewer images of war in the governor's suite, accepted the return of the Civil War paintings.

READY FOR THE NEXT CENTURY

Earlier histories of the Minnesota State Capitol make clear that it has not been loved by all. In *Minnesota's State Capitol: The Art and Politics of a Public Building*, Neil B. Thompson observed that many were critical because the building did not appear "midwestern" enough, whatever that may imply. Writer Thomas O'Sullivan explains that almost from the beginning, some derided it as striking but impractical. Both notions may be true, but it is also true that most Minnesotans embrace their Renaissance palace, so much so that they offered $310 million to prep the Beaux-Arts beauty for the next century.

With considerable assistance from a determined Channing Seabury, Cass Gilbert achieved what he set out to do: create a lavish and lasting classical monument to the people of Minnesota, a refined symbol reflective of the Euro-American journey from rawness to sophistication. This is intuitively understood by those who visit the capitol and contemplate the marriage of architecture and art that Gilbert plainly intended. And yet the capitol is more than a product of its architect or time. It also is a product of the people it represents, both past and present. It must strike a balance, retaining those

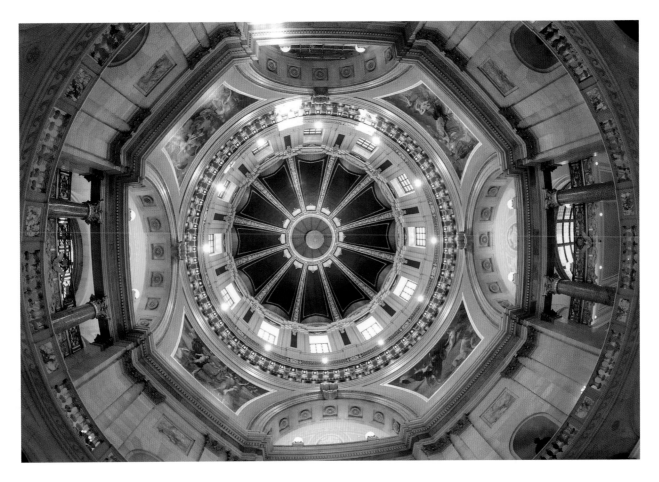

The dome from the center of the rotunda, December 20, 2016.

qualities that clearly inform us of its significance to our heritage while also reflecting and welcoming our evolving identity. In this regard, the debate over art in the statehouse has proved a valuable tutorial.

Despite its critics, the Minnesota State Capitol is and has been what a state capitol is supposed to be: an ideological superlative crafted to instill a sense of noble dignity in those who gather there to do the people's business. It is a place where intersecting ideas, disparate beliefs, and deeply held convictions shape the policies that guide the daily interactions of an increasingly diverse population. Gilbert's instincts were correct, for his capitol expresses these weighty sentiments in merely a glance.

NOTES ON SOURCES

Introduction

The photograph of the groundbreaking ceremony, which has been available at the Minnesota Historical Society (MNHS) for many years, is also included as the fifth image in the State Capitol Construction Album, a photograph album containing images of the capitol construction that was acquired by the MNHS in 2016 and is now held in Minnesota, Board of State Capitol Commissioners (hereafter BSCC), Records, 1892–1914, MNHS. All of the album's photographs date between 1896 and 1905, the time period covering construction of the building; most of these photographs appear to have been unavailable for public viewing for decades. They are the source of the gallery on pages 20–23.

For discussions of the groundbreaking and dedication ceremonies, see Neil B. Thompson, *Minnesota's State Capitol: The Art and Politics of a Public Building* (St. Paul: Minnesota Historical Society Press, 1974; rev. ed., 2005), 24–25, 103–5. Colvill was one of 25,000 Minnesotans who served in the Civil War; per capita, this was the largest contingent of any state, roughly equivalent to 750,000 soldiers today (see Pat Kessler, "Minnesota Military Leader Defending Civil War Art at Capitol," *CBS Minnesota,* December 7, 2015, at http://minnesota.cbslocal.com/2015/12/07 /minnesota-military-leader-defending-civil-war -art-at-capitol/). On Civil War flags, see "A Guide Trip through the Minnesota State Capitol, St. Paul, Minnesota," p. 4, typescript ca. 1950, in Miscellaneous Records Relating to the Minnesota State Capitol, 1893–1969, Minnesota State Archives, MNHS.

Prequel to a Monument

General histories of Minnesota include Theodore C. Blegen, *Minnesota: A History of the State* (Minneapolis: University of Minnesota Press, 1963), and William Lass, *Minnesota: A History* (New York: W. W. Norton, 1998). For population figures and settlement patterns, see June Drenning Holmquist, ed., *They Chose Minnesota: A Survey of the State's Ethnic Groups* (St. Paul: MNHS Press, 1981); Blegen, *Minnesota,* 306–7. For statistics on the lumber industry, see Blegen, *Minnesota,* 328. On iron mining, see David Walker, *Iron Frontier: The Discovery and Early Development of Minnesota's Three Ranges* (St. Paul: MNHS Press, 1979).

Planning Minnesota's Capitol

The story of the first two capitols, as well as of the 1905 capitol's planning, competition, and construction, are told in Thompson, *Minnesota's State Capitol.* See also BSCC, "First Biennial Report of the Board of State Capitol Commissioners Appointed to Construct a New Capitol for the State of Minnesota," January 1, 1895, in BSCC Records, MNHS; Jeffrey A. Hess and Paul Larson, *St. Paul's Architecture: A History* (Minneapolis: University of Minnesota Press, 2006), 18.

On Seabury, see Minnesota House Public Information Office, "Channing Seabury," *Session Weekly* (August 1994); Thompson, *Minnesota's State Capitol,* 6, 8; Denis P. Gardner, *Minnesota Treasures: Stories Behind the State's Historic Places* (St. Paul: Minnesota Historical Society Press, 2004), 212–14.

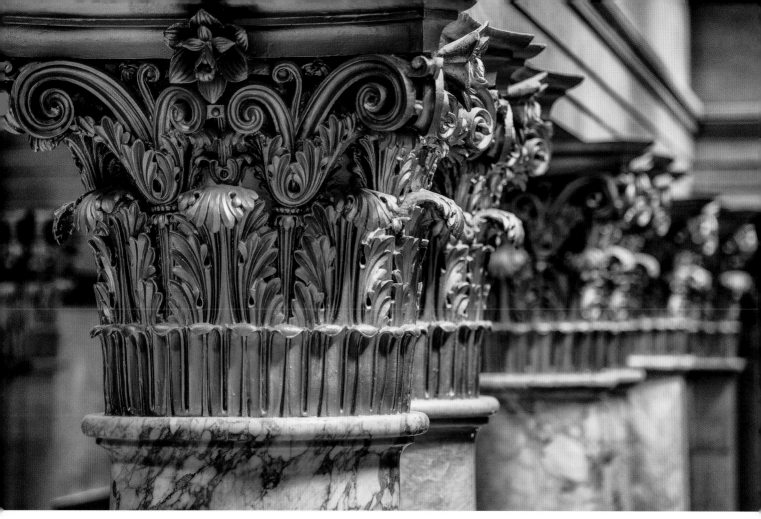

Detail of column capital, third floor.

Submission requirements are found in BSCC, *Instructions for Architects in Preparing Plans for a New Capitol to be Erected in St. Paul, Minn.* (St. Paul: Pioneer Press Company, 1895). Drawings of all five finalists are available in Thompson, *Minnesota's State Capitol,* 13–15.

Gilbert and Seabury were friends, and many believed this may have played a role in Gilbert's being awarded the commission. See Hammel, Green and Abrahamson, Inc., Schooley Caldwell Associates, Inc., and Luken Architecture, "Historic Structures Report for Repairs and Restoration to the Minnesota State Capitol," vol. 1, 1.8 (hereafter "Historic Structures Report"), available at the Minnesota Heritage Preservation Office, MNHS (hereafter MnHPO); Thompson, *Minnesota's State Capitol,* 12.

Thomas Jefferson is credited with his own architectural style, Jeffersonian Classicism; see Marcus Whiffen, *American Architecture Since 1780: A Guide to Styles* (Cambridge: MIT Press, 1992), 31–35, which also discusses the École des Beaux-Arts and the specifics of classical elements in Beaux-Arts design. For Jefferson, classicism in architecture was important because it harkened to antiquity and the lofty democratic ideals of Rome and Greece, ideals that were embraced by those making a new nation in America. Classicism prominently displayed in America demonstrated to the world that the country was every bit as sophisticated as Europe or anywhere else. An intriguing analysis of Jefferson's architectural philosophy is found in James Marston Fitch, *American Building: The Historical Forces that Shaped It* (New York: Schocken Books, 1977), 51–67.

For "Modern Traditionalist," see Sharon Lee Irish, "Cass Gilbert's Career in New York, 1899–1905" (PhD diss., Northwestern University, 1985), 1. A thorough treatment of the City Beautiful movement is available

in William H. Wilson, *The City Beautiful Movement* (Baltimore and London: John Hopkins University Press, 1989). See also Leigh Rothke, *Minnesota's Capitol: A Centennial Story* (Afton, MN: Afton Historical Press, 2005), 32; Brian Pease and Brian Szott, "Minnesota State Capitol: Overview of the Fine Art," 2015, unpublished report available at the MNHS, St. Paul, [1] (also available at https://mn.gov/admin /assets/overview-of-fine-art-in-capitol-MNHS _tcm36-74302.pdf). On Masqueray, see Alan K. Lathrop, "A French Architect in Minnesota: Emmanuel L. Masqueray, 1861–1917," *Minnesota History* 47 (Summer 1980): 42–56.

Frank Lloyd Wright was once described as "a handsome little man with flowing white hair, who has a genius for insulting people as well as for building beautiful houses to suit himself for other people to live in" (Laurence Schmeckebier, "Art on Main Street," *Minnesota History* 25 [March 1944]: 7). Sharon Irish explains that architects like Wright and Louis Sullivan (responsible for the clearly original and stunning National Farmers' Bank in Owatonna, Minnesota) were not fans of architectural offices like McKim, Mead and White, a firm with which a young Cass Gilbert worked and at which he was schooled in the practice of "mainstream architecture," which offered efficient designs "that recalled revered historical prototypes." Wright and Sullivan treated such firms as "historical foils." Nevertheless, McKim, Mead and White created building compositions welcomed by their clients and others, and the ever efficient Gilbert created architecture via historical precedents that the public and his clients welcomed as well. In fact, Gilbert was recognized with the Gold Medal for Architecture of the Society of Arts and Sciences for his embellishment of the New York skyline with the Woolworth Building, a skyscraper in Gothic attire that impressed even Wright, although he nevertheless still voiced his criticisms. For more information on Wright's and Sullivan's view of traditionalism, see Irish, "Cass Gilbert's Career," 4–6.

Cass Gilbert

For Gilbert's early years and travels, see Patricia Anne Murphy, *Cass Gilbert: Minnesota Master Architect* ([Minneapolis: University of Minnesota Gallery, 1980]), unnumbered pages 3–4, 12, 14; Geoffrey Blodgett, *Cass Gilbert: The Early Years* (St. Paul: Minnesota Historical Society Press, 2001), 23–36 ("slightest admiration," p. 27; photo of Château Chambord, p. 34); Cass Gilbert Society, "Cass Gilbert History," accessed October 2016, available at www .cassgilbertsociety.org/architect/bio.html; Irish, "Cass Gilbert's Career," 41, 44.

On Wren, see Cass Gilbert, *Reminiscences and Addresses* (New York: privately printed, 1935), 36. On the Endicott Building, see Thomas Lutz, "Pioneer and Endicott Buildings," May 1974, National Register of Historic Places Registration Form, available at MnHPO; Larry Millett, *Heart of St. Paul: A History of the Pioneer and Endicott Buildings* (St. Paul: Minnesota Museum of American Art, 2016). Interestingly, Gilbert was also a boyhood friend and MIT classmate of Clarence H. Johnston, who—like Gilbert—became one of Minnesota's most prominent architects.

Minnesota's State Capitol

For O'Sullivan quote, see *Northstar Statehouse: An Armchair Guide to the Minnesota State Capitol* (St. Paul: Pogo Press, 1994), 1–2. For overviews and specifics on the construction of the capitol, see "Historic Structures Report," 1.13, 1.14, 1.17 (power plant); Thompson, *Minnesota's State Capitol,* 23–24, 27 (quotations attributed to the architects), 35, 43–45 (laying of cornerstone), 60–61; Rothke, *Minnesota's Capitol,* 29; Labor Education Service of the University of Minnesota, "Who Built Our Capitol?" 2013, video documentary and website highlighting the workers who labored on the Minnesota State Capitol, available at whobuiltourcapitol.org.

The capitol was constructed using twenty-three types of stone, including sixteen varieties of marble. See Minnesota Chapter, Society of Architectural Historians, "The Minnesota State Capitol Restoration," *With Respect to Architecture,* February 2016.

The exterior description comes from a site visit by the author on October 20, 2016, as well as the State Capitol Construction Album. Descriptive information is also available in Brooks Cavin, "Minnesota State Capitol," National Register of Historic Places Registration Form, October 1971, MnHPO. Additional descriptive information is in "Historic Structures Report," 3.1.

On interior construction, see "Historic Structures Report," 1.16–1.17; Thompson, *Minnesota's State Capitol,* 57, 63. Much of the interior description is drawn from the author's visits to the capitol, but numerous digital photographs of the capitol are available on the internet. The new capitol was featured in a number of publications, including the *Western Architect,* which devoted an entire issue to the subject. See *Western Architect* 4 (October 1905). For other sources, see "A Guide Trip," 1, 4; Cavin, "Minnesota State Capitol"; Cass Gilbert, "Brief Description of the New Capitol Building, St. Paul, Minn.," 1905, pamphlet available at Gale Family Library, MNHS (includes descriptions of marble). Copies of Gilbert's 1903 revised capitol drawings are in "Historic Structures Report," 1.21–1.45. On women's restrooms, see Sheila Dickinson, "Battle Rages Over Racist Paintings in the Minnesota State Capitol," *City Pages,* February 24, 2016; Brian Pease, site manager, Minnesota State Capitol Historic Site, email to the author, October 26, 2016, in author's possession. On locations of various offices, see "Historic Structures Report," 1.21–1.45, 1.91. On the Rathskeller and the cantilevered staircase, see Thompson, *Minnesota's State Capitol,* 83, 85. Details of the Rathskeller's restoration can be found at www.mnhs.org/preserve/rathskeller.php.

Capitol Art

For overviews and discussions of the art in the capitol, see Pease and Szott, "Minnesota State Capitol," [1] ("Nothing will give"), [2] (figures on art costs); Thompson, *Minnesota's State Capitol,* 87–95; O'Sullivan, *Northstar Statehouse;* "A Guide Trip," 4; Subcommittee on Capitol Art, "Final Report to the Minnesota State Capitol Preservation Commission," August 15, 2016, p. 41, copy available at https://mn.gov/admin/assets/2016-08-15-art-subcommittee-final-report_tcm36-252309.pdf.

On Walker, see Pease and Szott, "Minnesota State Capitol," n.p.; Julie C. Gauthier, *The Minnesota Capitol: Official Guide and History* (St. Paul: n.p., 1908), 23–24. On La Farge and Blashfield, see Frank Jossi, "Minnesota State Capitol: The People's Art Gallery," *St. Paul Legal Ledger Report* 21 (September 2011): n.p. ("the true artist").

Brioschi Studios traces its origins to the Brioschi-Minuti Company, an enterprise founded by Italian immigrants Carlo Brioschi and Adolfo Minuti in 1909. The company had a long history with architect Emmanuel Masqueray and successor firms working on the St. Paul Cathedral and the Basilica of St. Mary in Minneapolis, as well as other buildings. The Brioschi-Minuti Studio building is located on the south side of University Avenue in St. Paul, not far west of the Minnesota State Capitol. For additional information, see William E. Stark, Stark Preservation Planning LLC, "Brioschi-Minuti Company Building," May 2015, National Register of Historic Places Registration Form (DRAFT), available at MnHPO; Jossi, "Minnesota State Capitol."

Capitol as Civil War Monument

The capitol's Civil War art is discussed in Thompson, *Minnesota's State Capitol,* 94–95; O'Sullivan, *Northstar Statehouse,* 78–85; Subcommittee on Capitol Art, "Final Report," 20; Pease and Szott, "Minnesota

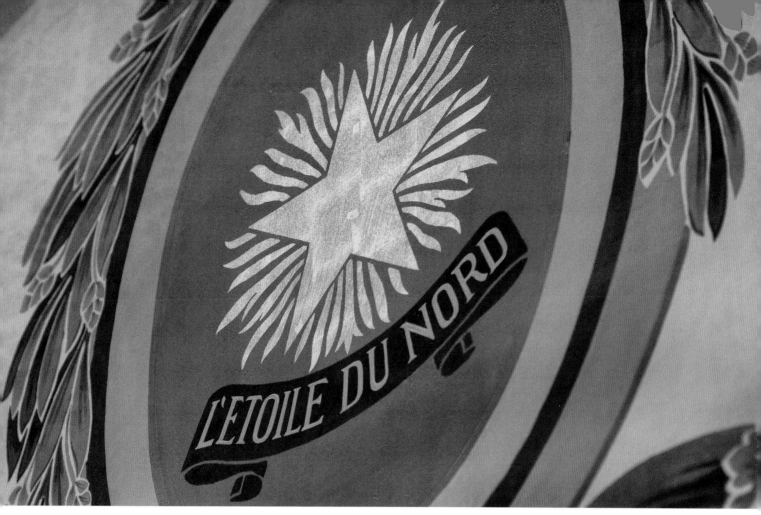

Stencil on wall of entryway, second floor.

State Capitol," n.p. On Minnesota's capitol buildings as repositories of Civil War history and the evolution of Gilbert's thinking, see Kessler, "Minnesota Military Leader"; Pease, email to author, October 26, 2016; Pease and Szott, "Minnesota State Capitol," n.p.; "Historic Structures Report," 1.16. On Killdeer Mountain, see Paul N. Beck, *Columns of Vengeance: Soldiers, Sioux, and the Punitive Expeditions, 1863–1864* (Norman: University of Oklahoma Press, 2013), 202–19.

Capitol Furnishings

This discussion of the furnishings in the capitol leans heavily on Minnesota Historical Society, *Attention to Detail: 1905 Furniture of the Minnesota State Capitol* (St. Paul: Minnesota Historical Society, 1989). A concise history of Herter Brothers is found in Wade Alan Lawrence, "Herter Brothers and the Furniture

of the Minnesota State Capitol, 1903–1905" (master's thesis, University of Delaware, 1987), 6–19. In an appendix, Lawrence provides a detailed catalogue of all of the special and standard furniture produced for the capitol.

The Capitol Builders

On Butler-Ryan, see extensive discussion in Thompson, *Minnesota's State Capitol* ("smooth individual," p. 43); "Historic Structures Report," 1.19. On Aus and the design of the dome, see "Historic Structures Report," 1.18; Thompson, *Minnesota's State Capitol,* 53–60. On Guastavino, see "Historic Structures Report," 1.18. On Truesdell, see Gardner, *Minnesota Treasures*, 81–84.

A good source on the stoneworkers who completed the capitol is John T. Sielaff, "The Stonecutters,"

Minnesota History 64 (Spring 2014): 4–17 ("The saws are two long strong steel blades," p. 8, cited to *St. Paul Globe,* April 18, 1898, p. 2). On Bullard, see Susan Granger and Kay Grossman, "Bullard, Casiville, House," February 1996, National Register of Historic Places Registration Form, available at MnHPO, 8.2–8.4 (African American tradesmen from the South, 8.3); Laura E. Weber, "The House that Bullard Built," *Minnesota History* 59 (Summer 2004): 62–71. On Olson, Rachac, Arthur, and those who died during the construction, see "Who Built Our Capitol?"; Sielaff, "Stonecutters," 13, 15. On the design competition, see Paul Mandell, "Capitol Workers Plaque Design Competition for Sixth-graders—Dec. 8 Deadline," *Workday Minnesota,* November 22, 2016.

Capitol Mall

A good history of the capitol mall is in Marjorie Pearson, "Approaching the Capitol: The Story of the Minnesota State Capitol Mall," *Minnesota History* 65 (Winter 2016–17): 120–35. She notes that the watercolor is reproduced in Michael Conforti, ed., *Art and Life on the Upper Mississippi, 1890–1915* (Newark: University of Delaware Press, 1994). See also Marjorie Pearson, et al., "Supplemental Historic Properties Investigations and Evaluations for the Central Corridor Light Rail Transit Project," June 27, 2008, completed for Metropolitan Council, St. Paul, 75.

A copy of Capitol Approaches Commission, *Report of the Capitol Approaches Commission to the Common Council of the City of St. Paul,* 1906, is available at Gale Family Library, MNHS ("This approach will afford," p. [2]; "beauties [were] hidden" and seven suppositions, p. [4]). The *Fortune* article is discussed in Hess and Larson, *St. Paul's Architecture,* 171–72.

Gilbert's report is brief but nevertheless more detailed than presented here. In it he suggests a very long central approach extending from the capitol through Seven Corners and to a new bridge spanning the Mississippi River and a memorial marker to state pioneers. See Cass Gilbert Inc, Architects, *Report on Capitol Approaches* (New York: Cass Gilbert Inc., 1931); Pearson, "Approaching the Capitol," 128–29; Pearson, "Supplemental Historic Properties Investigations," 75. For post–WWI developments, see Larry Millett, *AIA Guide to the Twin Cities* (St. Paul: Minnesota Historical Society Press, 2007), 359; Hess and Larson, *St. Paul's Architecture,* 180–81; Pearson, "Approaching the Capitol," 129–31; Minnesota Capitol Preservation Commission, "Comprehensive Master Plan," February 2012, copy available at mn.gov /admin/capitol-restoration, 8–9; "Historic Structures Report," 1.49, 1.91. Information on the CAAPB is available at the board's website, mn.gov/caapb/.

The Capitol at Work

For "beauty pile," see O'Sullivan, *Northstar Statehouse,* 100. On changing uses, see "Historic Structures Report," 1.49, 1.91. On various issues addressed at the capitol, see these entries in MNopedia, the online encyclopedia of Minnesota history, http:// www.mnopedia.org: Eric Weber, "Minnesota Woman Suffrage Association"; Ehsan Alam, "Near v. Minnesota, 1931"; R. L. Cartwright, "Farmers' Holiday Association in Minnesota"; Katherine Goertz, "WPA Federal Art Project, 1935–1943"; Joseph Manulik, "Mississippi River Oil Spill, 1962–1963"; Tom O'Connell, "Humphrey, Hubert H. (1911–1978)." See also Gardner, *Minnesota Treasures,* 57–61; O'Sullivan, *Northstar Statehouse,* 98; Laurie Cohen and Christopher Drew, "Farmer Protests Gaining Steam as Crisis Worsens," *Chicago Tribune,* January 27, 1985; Mordecai Lee, *The Philosopher-Lobbyist: John Dewy and the People's Lobby, 1928–1940* (Albany: State University of New York Press, 2015), ix–xi.

Capitol Restoration

Information on various renovations is from Brian Pease, site manager, Minnesota State Capitol Historic Site, interview with author, July 8, 2016, transcript

Detail of decorative plaster on the ceiling of the Senate retiring room.

in possession of author; Historic Structures Report, 1.48. The capitol was listed in the National Register of Historic Places in 1972. On furnishings, see MNHS, *Attention to Detail,* 3.

On the decision to restore the building, see Lee Ann Wahi, "Fixing the State Icon," *Twin Cities Daily Planet,* April 20, 2012; "Comprehensive Master Plan," 3; Brian Johnson, "Minnesota's State Capitol Dome Renovation Moving Forward, More Maintenance Work Awaits," *St. Paul Legal Ledger Report,* May 27, 2016; Pease and Szott, "Minnesota State Capitol," n.p.; "Historic Structures Report," 1.3 (quotations). Coverage of the project includes Dave Montgomery, "Rush on to Finish $310M Renovation," *St. Paul Pioneer Press,* August 16, 2016; Maya Rao, "State's Crown Jewel Gleams Again," *Minneapolis Star Tribune,* August 2, 2016.

On the art restoration, see Rachel E. Stassen-Berger, "Capitol Restoration Project Threatens to Bust its

$270M Budget," *St. Paul Pioneer Press,* March 26, 2015; Patrick Condon, "Capitol Renovation Project Needs $30M More from Lawmakers," *Minneapolis Star Tribune,* March 28, 2015; Pease interview, July 8, 2016; Pease and Szott, "Minnesota State Capitol," n.p.; Robert Herskovitz, conservator, interview by author, October 26, 2016, transcript in possession of author.

Before the restoration, the Senate had thirty-nine offices in the building; afterward, it had four. Sixty-three senators now are housed in the new Minnesota Senate Building. Members of the House have been located in the nearby State Office Building for some time. See Patrick Condon, "Remodeled Capitol Expands Public Space with Dining Rooms, Info Center," *Minneapolis Star Tribune,* January 22, 2015; Michael J. Klingensmith and Scott Gillespie, "Special Session Deal is Overdue," *Minneapolis Star Tribune,* January 9, 2016; Rachel E. Stassen-Berger and Bill

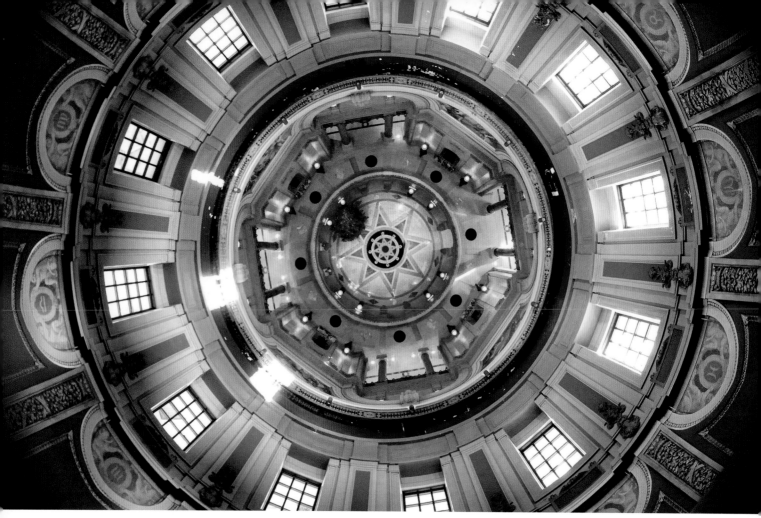

Looking into the rotunda from above the interior dome, before the restoration, December 4, 2012.

Salisbury, "Lawmakers, Tension Return," *St. Paul Pioneer Press,* March 9, 2016; Pease interview, July 8, 2016; Doug Belden, "Minnesota Capitol Renovation Faces Delays over Space Dispute," *St. Paul Pioneer Press,* January 13, 2015 ("My view"); Subcommittee on Capitol Art, "Final Report," 7; "Comprehensive Master Plan," 15–25.

Angst over Art

The art controversy was widely covered by newspapers throughout Minnesota, and the vast majority of articles were evenhanded; those quoted in them largely were considerate and thoughtful in their views. See Jon Tevlin, "With Capitol under Renovation, Debate begins on which Art is Appropriate when it Reopens," *Minneapolis Star Tribune,* December 1, 2015 ("It was tense"); Jossi, "Minnesota State Capitol," n.p.; Pease and Szott, "Minnesota State Capitol," n.p.; Dickinson, "Battle Rages"; "Art and Our Relationship to the Environment: Images from the State Capitol," *Healing Minnesota,* February 17, 2016; Shelly Buck, "Minnesotans, It's Time to Move Offensive Art out of the People's House," *Minneapolis Star Tribune,* March 16, 2016; Chris Steller, "Committee Weighs how to 'Keep' Capitol's Controversial Art," *Finance and Commerce,* January 14, 2016.

Ready for the Next Century

See Thompson, *Minnesota's State Capitol,* 106–7; O'Sullivan, *Northstar Statehouse,* 100.

INDEX

Photo credits

Through the generosity of the Minnesota Department of Administration, Senate Media Services, and House Public Information Services, images taken by Cathy Klima, David Oakes, and Tom Olmscheid are presented in this book. The Department of Administration's Flickr account (www.flickr .com/photos/capitol-restoration/) includes hundreds of additional shots by Cathy Klima. Additional images by Tom Olmscheid, who documented the restoration after his retirement, are also included.

David Oakes, courtesy Senate Media Services: i, ii, iv, v, vii, viii, x, 30 top right and bottom, 31 bottom left and top right, 35 bottom, 42, 44 right, 48, 56, 71 bottom, 84, 87, 89.
Cathy Klima, courtesy Department of Administration: vi, 28, 29, 31 top left and bottom right, 33, 37 top and bottom, 70, 71 top, 76 top and bottom, 77.
MNHS: 1, 2, 3, 6, 7, 9, 15 top and bottom, 19, 24, 25, 26 (Board of State Capitol Commissioners Papers), 41, 44 left (Board of State Capitol Commissioners Papers), 45 top, 47, 49, 51 (2008.32.1.A-XX), 53 (from *Report of the Capitol Approaches Commission to the Common Council of the City of St. Paul* [St. Paul: Pioneer Press, (1906)]), 54 (Kenneth Melvin Wright), 55 top (St. Paul Dispatch and Pioneer Press), 55 bottom (Marv Kruskopf), 58, 59, 63, 79.
MNHS, Capitol Photo Album: 11, 18 top and bottom, 20–23, 32, 35 top, 50.
Tom Olmscheid, TOMO Photography (© Tom Olmscheid; www.tomophotography.com): 12, 13, 30 top left, 34 bottom, 38, 39, 65, 66, 67, 68, 69, 72–75, 78, 82, 90.
Hannah Boehme: 26 (illustration detail).
Joe Mamer Photography: 27.
Doug Heimstead: 30 (quadriga), 62.
Willette Pictures: 34 top.
Alan Ominsky: 46.
Jerry Blakey: 49.
Tom Olmscheid, courtesy House Media Services: 60–61, all images.